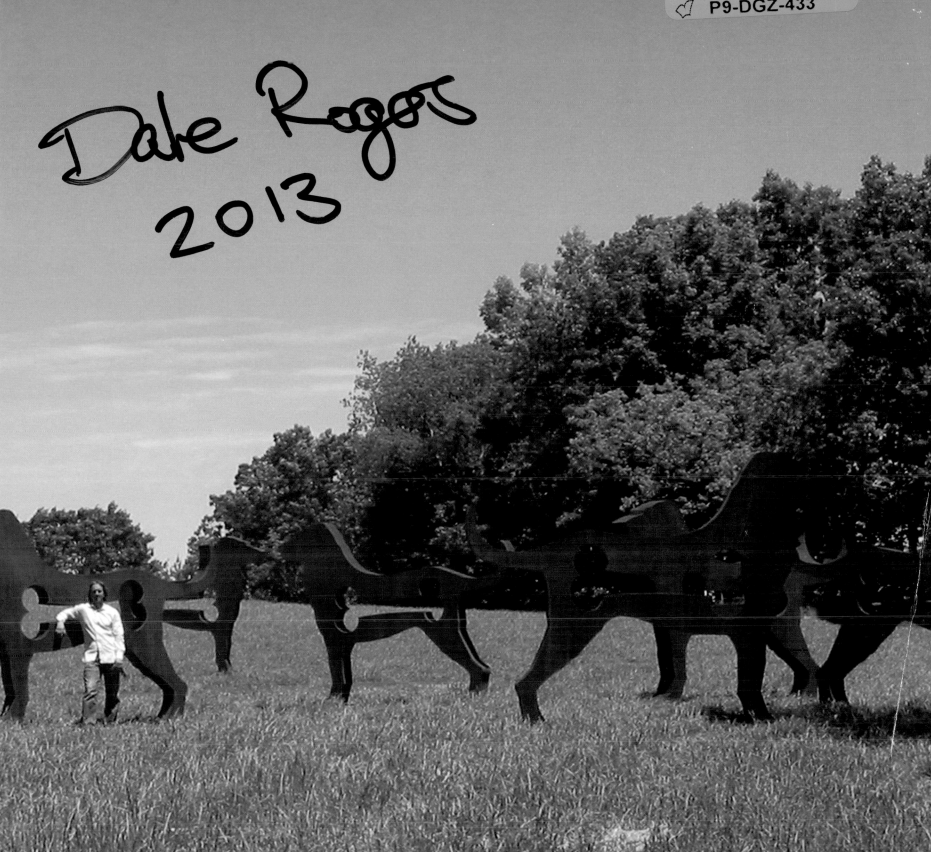

The story and art of
Dale Rogers

Sherri Fowler-Nagle

three
bean press

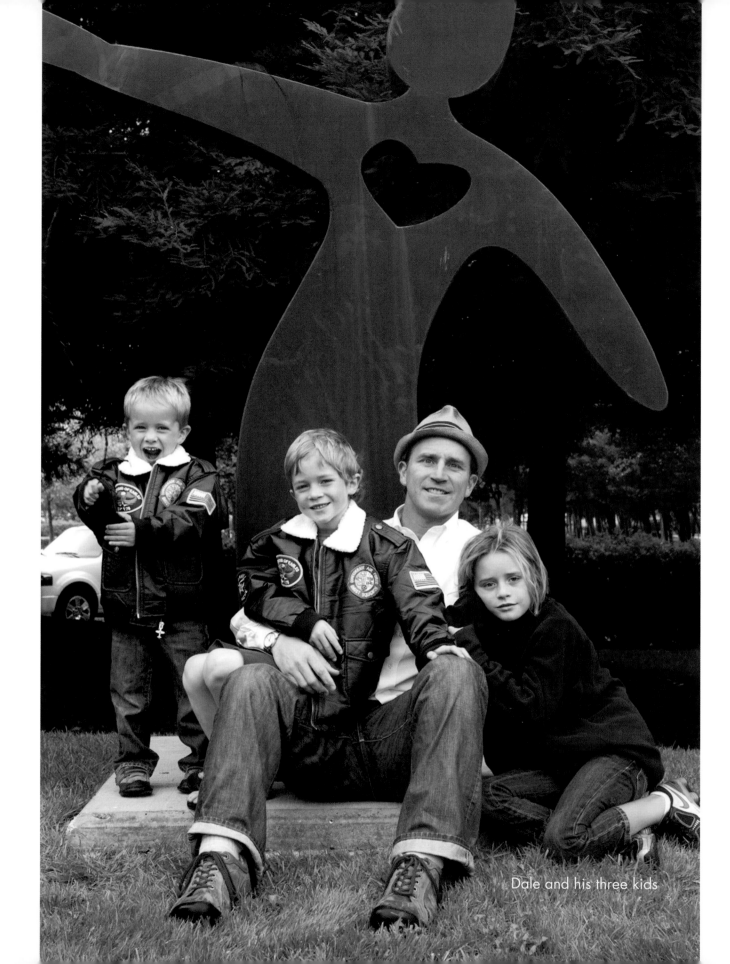

Dale and his three kids

The Story and Art of Dale Rogers
Published by:
Three Bean Press, LLC
P.O. Box 301711
Jamaica Plain, MA 02130
info@threebeanpress.com • www.threebeanpress.com

Publishers Cataloging-in-Publication Data
Fowler-Nagle, Sherri
The Story and Art of Dale Rogers / by Sherri Fowler-Nagle.
p. cm.

Summary: Dale Rogers Jr. is an artist based out of Haverhill, Massachusetts, who specializes in large-scale metal sculpture. This book chronicles his life to date and his work, both private and public.

ISBN 978-0-9767276-9-9

[1. Art—Nonfiction. 2. Biography—Nonfiction. 3. Sculpture—Nonfiction. 4. Dale Rogers—Nonfiction.] I. Title.

LCCN 2012939500

Printed and bound in Guangzhou, China, by Everbest Printing Company, Ltd., through Four Colour Print Group in June 2012. Batch 106559.1

10 9 8 7 6 5 4 3 2 1

For more information on Dale Rogers Studio and its sculptures, please visit www.dalerogersstudio.com.

Front cover: G Swirl, Clipper City Rail Trail, Newburyport, Massachusetts, by Dale Rogers
Inside front cover: Dale Rogers stands with his iconic American Dog sculptures for "The Big Dog Show."
Inside back cover: "Metal Monkey Mania" on the Blue Bridge at ArtPrize 2011 in Grand Rapids, Michigan

Acknowledgments

Dale would like to say a special thank-you to the following people, as they have been particularly influential in his career and in the journey this book has taken....

Mark Semler, who was instrumental in the early stages of Dale's career path.

Michael and Susan Guarnieri, clients of Dale's who went the extra mile, working diligently to produce and publish Dale's first book—*The Elemental Works of Dale Rogers*, 2011.

Jason Vining, for the partnership that has grown over the years between Dale Rogers Studio and Salem Metal Fabricators.

His family, for their overall support.

This book has been a seed of an idea for some time here at Dale Rogers Studio, but it never would have come to completion without Sherri Fowler-Nagle's dedication.

—Allisa Rudden, "clickety-clacking" on the keyboard as usual, while Dale is busy designing, welding, and exhibiting.

Dale Rogers

Table of Contents

Preface
Author's Note

When I first met Dale Rogers Jr., a large-scale metal sculptor and the founder and owner of Dale Rogers Studio in Haverhill, Massachusetts, I have to admit I was shocked. You hear "large-scale metal sculptor," and you envision an artist working in an oversized warehouse. But Dale's studio is actually run out of his home in a basement office and attached garage. You would not believe what he is capable of producing in this space. Two rooms. Just two rooms.

The office is where Dale develops his designs using 3-D software. He shares this room with Allisa Rudden, his office manager and bookkeeper; his dog, two cats, a fish, and a lizard; a small refrigerator; the ever-critical coffeepot; and, now, myself. In the adjacent garage, Dale and two other welders complete the metal cutting, welding, grinding, and finishing. I have worked at Dale Rogers Studio for some time now and have developed a better understanding of the operation, but I am still in awe. Two rooms. That is it.

How did Dale arrive as a sculptor in this space? What factors shaped his life, his creativity? What beliefs and business practices contribute to his success? This book takes a look at Dale's life and the development of his career and provides insight to answer these questions.

—Sherri Fowler-Nagle

chapter 1

Early Beginnings

Dale Rogers Jr. grew up on his family's dairy farm in Haverhill, Massachusetts. The farm, which is now a water-bottling plant, can be seen from Dale's backyard today. With farm life as the backdrop, Dale and his older brother, Harold, learned early on how to be creative in finding ways to entertain themselves. The two boys were free to explore nature in the fields of the farm where they would run, build forts, and investigate everything they could. As they grew older and began to ride bikes, their territory expanded.

From a young age, Dale was designing and creating, using whatever materials he had around him. His imagination and creativity were his entertainment, and the supply was endless.

Both Dale and Harold worked on the farm; their parents made sure they learned the importance of hard work and saving money. One year, the boys decided they wanted four-wheelers, but they were told by their parents that they would have to save their money first. Marcia Rogers— Dale's mother—never expected them to meet this goal, but by the end of the year the boys had saved enough, and

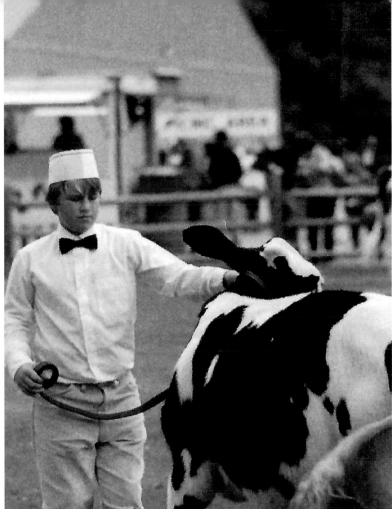

the four-wheelers were soon purchased. The persistence and certitude that Dale exhibited in his quest for that four-wheeler has continued throughout his life and career.

For as much fun as Dale had on the farm, he struggled in school, and in third grade he was diagnosed with a learning disorder that required him to spend most of his school days in a single classroom with only a few other students. School became especially challenging. Marcia remembers how difficult these early years were for Dale and how his frustrations were expressed through temper tantrums.

According to his mother, a fifth grade teacher named Ann Lopresti really changed Dale's life. Marcia credits this teacher with recognizing his artistic abilities and building Dale's self-esteem and confidence. His high-school art teacher, Sue Paridis, also fostered his creativity, encouraging him to experiment with many different art forms and media.

Dale also discovered snowboarding while in high school, and he competed throughout New England. In his junior year, he ranked third in New England. The creative release Dale found in his art and the physical release of his

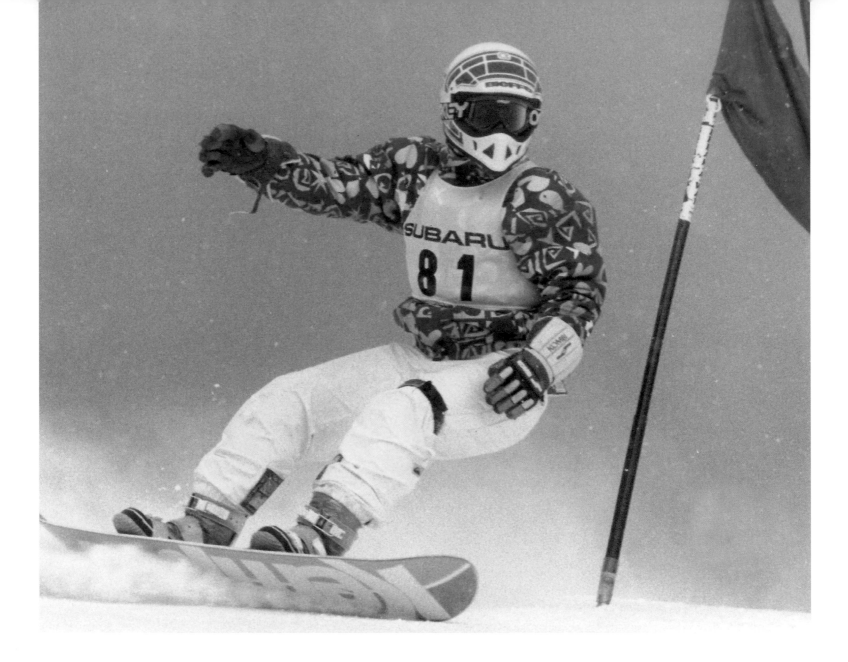

sport made high school bearable for Dale, and he learned to adapt to his reading and writing struggles.

Dale graduated from high school, and although he clearly had an affinity for art, he believed it was not a valid career path. He attended Southern New Hampshire University in Manchester, New Hampshire, where he majored in business, giving up his interest in art. During his freshman year, Dale met Gene Goldberg. Dale had the lowest SAT scores of the entering freshman class and Gene had the lowest GPA. By the end of freshman year, Dale and Gene were best friends and were ranked as first and second in their class. Dale credits their success in college to their difficulties in high school. By this point, they each knew the learning styles that worked best for them, and the college environment catered to these methods more

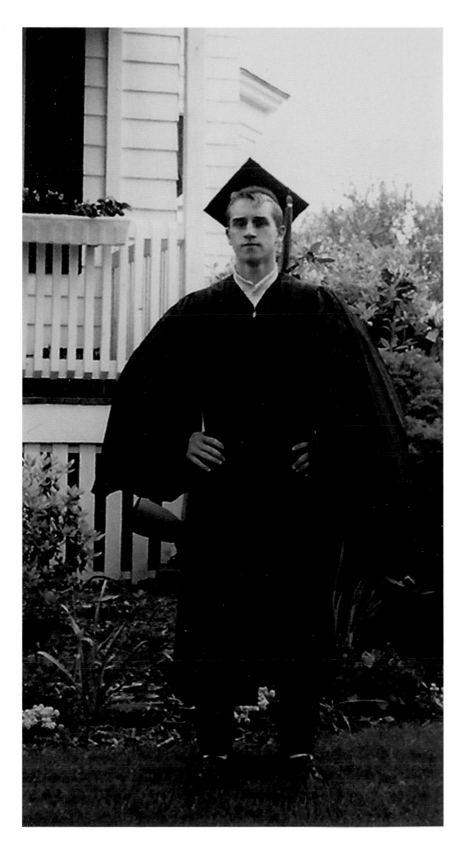

than high school had. Equipped with this knowledge, Dale and Gene excelled quickly; neither one ever looked back.

In college, Dale discovered his love for travel. He and Gene embarked on Semester at Sea and traveled around the world by ship on a 14-country tour. Jamie Munson and Mike Regan, also on the ship, soon became friends with Dale and Gene. These four remain close today, celebrating many of life's milestones with one another. On this voyage, Dale garnered an appreciation for other cultures and habitats, which later influenced several of his sculptures.

At the end of their Semester at Sea, the ship docked at a port in the state of Washington. Dale had discussed with his parents his desire to take a solo cross-country bike trip once his Semester at Sea was over. His parents flew west and, after negotiating a plan for Dale to check in with them along his journey, outfitted him for his adventure. Marcia states, "I was sure that after all that time at sea, Dale would want to come home and spend time with his family. He proved me wrong!"

Dale intended to train for his bike trip, but by the time he got to Washington the planned start date was only five days away. He spent those days drinking beer and smoking cigarettes instead and immediately regretted it once he began his trip; the first 500 miles were nothing but mountains. Dale spent 35 days crossing the country on his bicycle. Today, Dale credits the trip with teaching him

about himself: his love of exercise, the outdoors, the generosity of others, and the United States as a whole.

After graduating from college, Dale started working in the family business, which had been converted from a dairy farm and milk-bottling plant to a water-bottling plant called Spring Hill Water. He continued to travel and invested in the stock market to fund his adventures. He visited India several times and also completed another solo bike trip, this time from east to west. Upon his return, he met his future wife, Heather Kulik. They dated for a few years and married in 1999. Heather and Dale opted for a small wedding and used the money to fund a four-month honeymoon instead. They left in early 2000 and visited Mexico, Japan, Hong Kong, Thailand, Vietnam, India, Nepal, Paris, and London. Some of these destinations were selected so they could purchase sterling silver jewelry for Heather's business at the time.

After they returned from their honeymoon, Dale returned to work in his new role as Filler Operator of the plant, where he was responsible for keeping the bottling equipment running. He would perform what he terms "quick-and-dirty welding" on the equipment to improve plant efficiency. Due to the nature of the job, there was downtime, and Dale found himself relying on his natural-born creativity to fill these moments. He began experimenting with welding more during the slow times and found that he liked it, so he retrained himself in order to accomplish more accurate welds. Dale learned about the push-pull effects of metal as he pieced different shapes together, anticipating how the material would react and how he could manipulate it. His interest was piqued; he became consumed by thoughts of metal and how he could sculpt it. A passion was born.

chapter 2

Early Pieces, Early Lessons
2001 through 2003

In 2001, after six years at Spring Hill Water, Dale decided to leave the family business to create and sell his metal art full time. Heather and Dale wanted a large family, so Dale felt this was the opportunity to take the risk and make a change, before they had children. Once they started a family, it would be difficult to consider a career move.

Dale Sr., were "surprised, but pleased with his decision for two reasons: firstly, he would now be able to use his creativity in the way that God intended, and, secondly, he was secure enough in his relationship with us to move away from the family business, something no one had really done before."

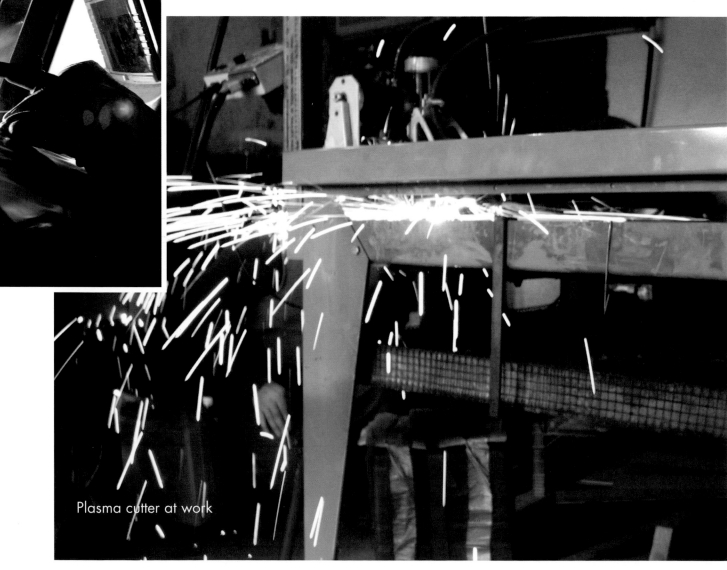

Dale TIG welding in the shop

Dale's mother says that she and her husband,

Dale invested in a TIG welder, a plasma cutter, and metal materials and set up his shop in the garage of his home.

Plasma cutter at work

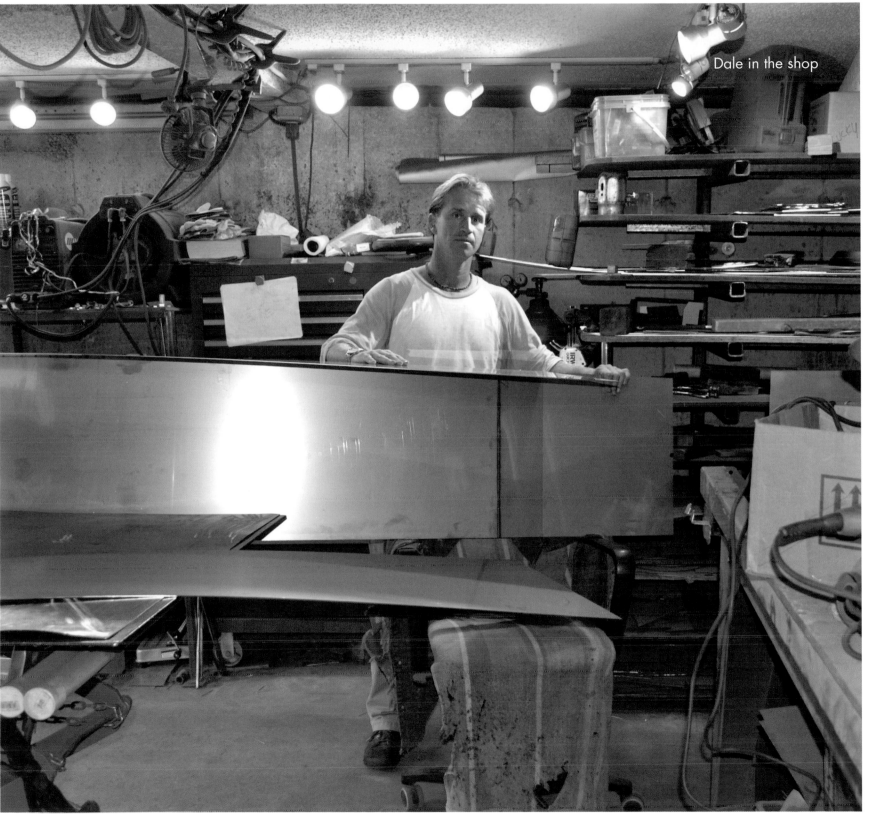

Dale in the shop

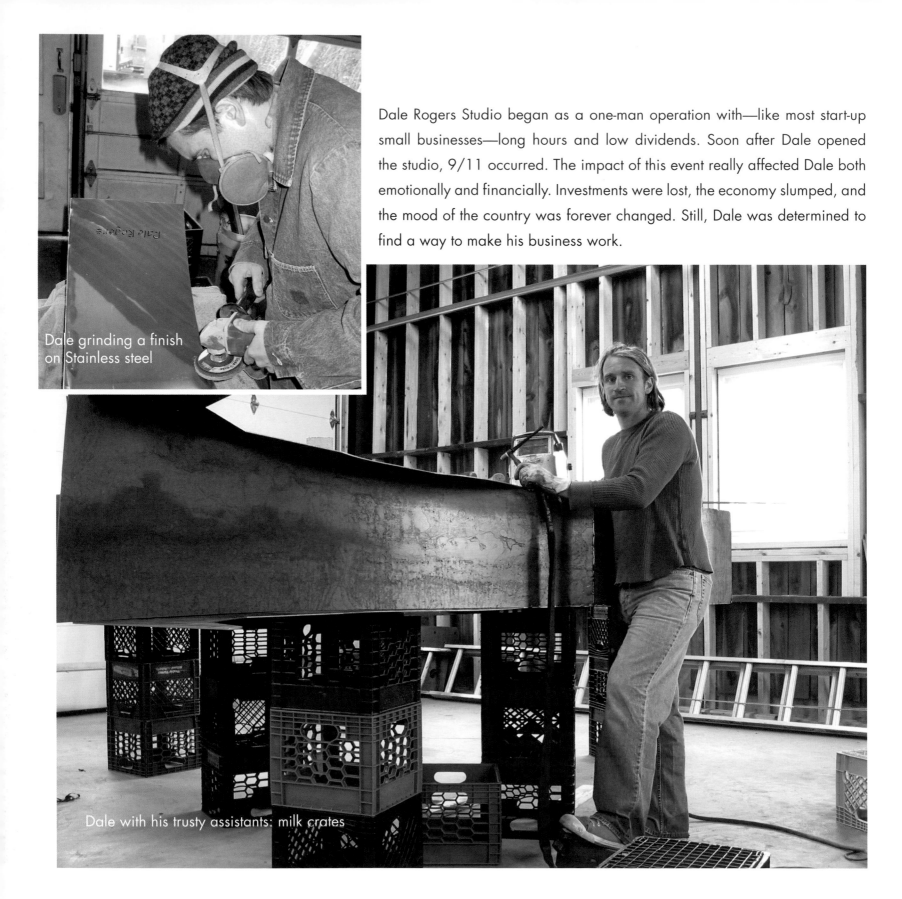

Dale grinding a finish on Stainless steel

Dale Rogers Studio began as a one-man operation with—like most start-up small businesses—long hours and low dividends. Soon after Dale opened the studio, 9/11 occurred. The impact of this event really affected Dale both emotionally and financially. Investments were lost, the economy slumped, and the mood of the country was forever changed. Still, Dale was determined to find a way to make his business work.

Dale with his trusty assistants: milk crates

In 2002, Heather and Dale had their first child, Beatrice. In 2005, Dale Rogers III, known as Tripp, was born, and Jude followed in 2006. In order to find time to spend with his young family, Dale would often work from 2 to 7 a.m., and then again for a few hours in the afternoon. Because it was a one-man shop, Dale's favorite assistants were milk crates. Those crates were the extra set of hands he needed but didn't have, and they are still in constant use today.

As difficult as things were in the beginning, Dale was excited about his art and his vision for Dale Rogers Studio. His creativity fueled his energy as he continued to develop and grow his business.

Early work out of Dale Rogers Studio consisted of functional art—wine racks, clocks, mirrors, signs, furniture—custom work, and, in Dale's words, "huge, metal, naked chicks" based on classic Vargas nudes. These items were on a smaller scale than Dale's current work and required him to create and sell larger quantities to break even.

Dale began aggressively peddling pieces to local galleries, even pulling his art from his van and getting a gallery owner to look at it—all while double-parked. He successfully placed his art in Chameleon in Newburyport, Massachusetts, and L'Attitude Gallery of Boston. It was a start, but Dale knew he needed to expand beyond the local market.

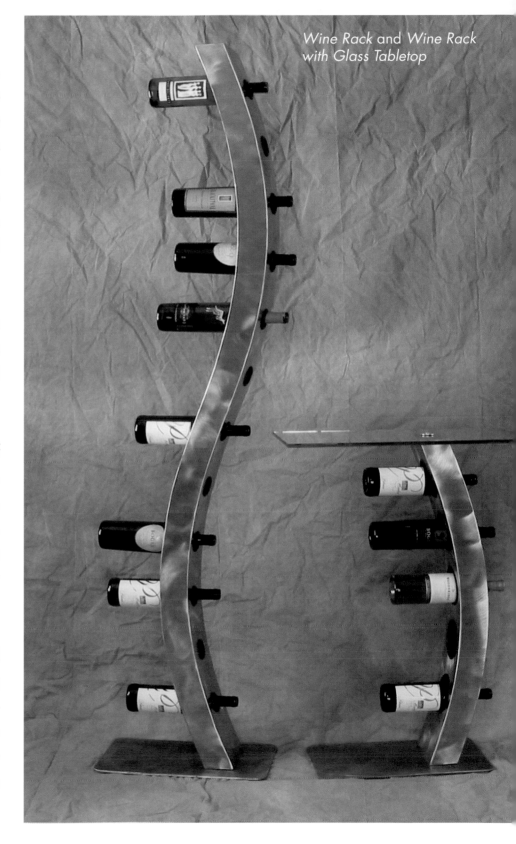

Wine Rack and *Wine Rack with Glass Tabletop*

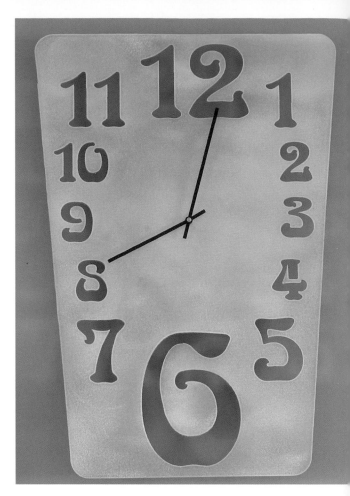

Big 6 clock

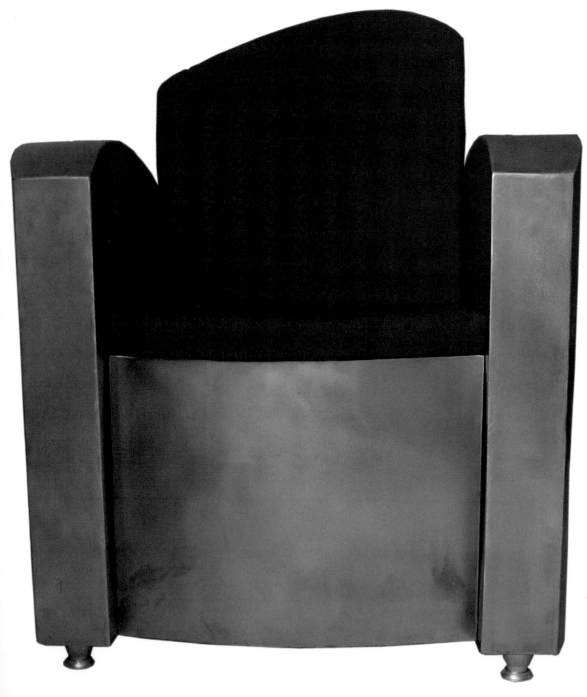

Red Chair

Capitalizing on his business skills, he began to portray Dale Rogers Studio as a large, viable business that would be attractive to galleries nationwide. He co-marketed with galleries in order to be featured in publications that he could not afford on his own, and he used trade-show publications picturing his work as marketing materials.

Juried art shows seemed like the natural next step, so Dale applied to the largest he could find. New York's Artexpo and Buyers Market of American Craft trade show, among others. These shows required that Dale's work be reviewed by a panel or jury responsible for accepting or denying applicants. They are extremely competitive to

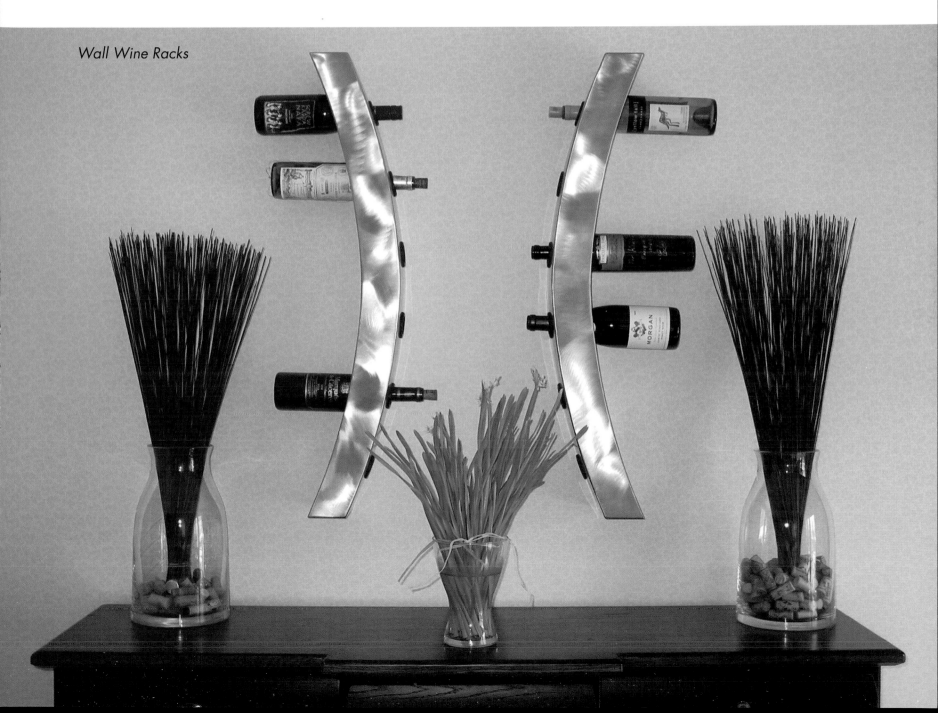

Wall Wine Racks

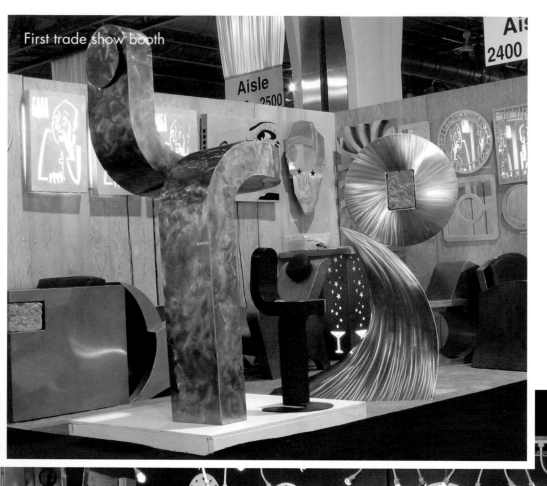

First trade show booth

get into; most average 1,500 applicants for 200 spots.

Depleting his savings to cover entrance fees, Dale learned a valuable lesson early on: booth design was critical to trade-show success. Indeed, his overcrowded, under-decorated early booths proved a setback—both for the studio and Dale's bank account.

Dale's redesigned booth debuted at his second Buyers Market of American Craft trade show

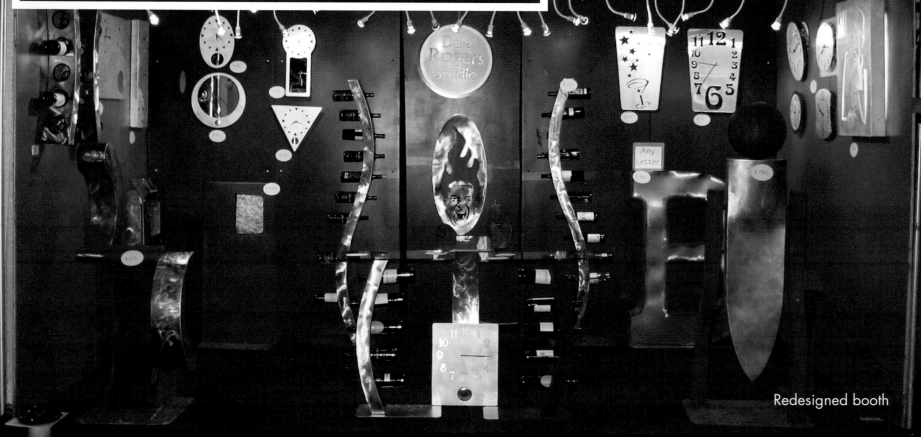

Redesigned booth

in February 2004. Lighting was added, the walls were painted, and an improved layout allowed clients the ability to view his collection from a better vantage point.

Dale attended The Boston Wine Expo in 2003 where he showed his wine racks, mirrors, lights, tables, and his Vargas-style nudes. An older woman stopped at his booth and told him that his work was pornographic.

Taken aback, Dale replied that his work evoked the classic pinup girls of an earlier time, that these were similar to the Vargas nudes that had been on the cover of *Esquire* magazine in the '30s. "*Esquire* magazine," she replied, "was considered pornographic in my time!" This experience impressed upon Dale the importance of focusing on the demographics of his buyers and the need to create art that would appeal to them.

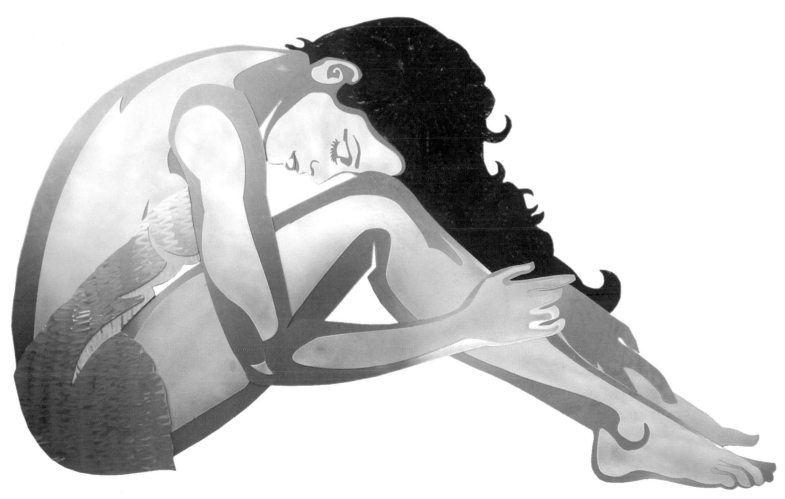

Crissie

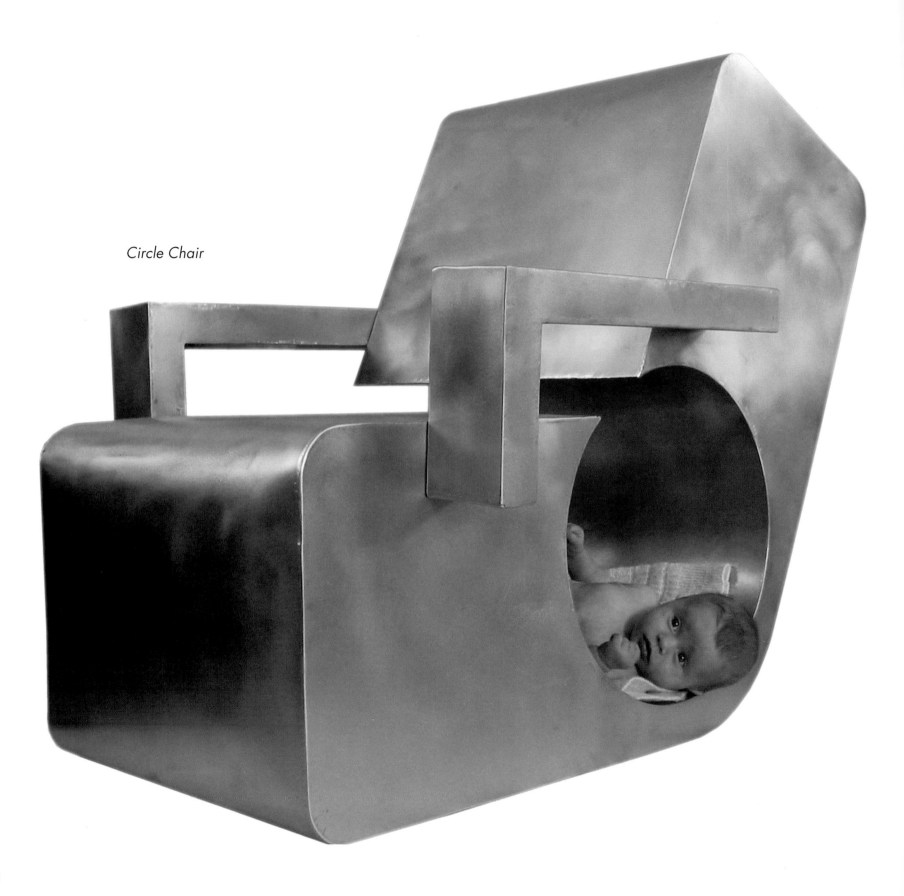

Circle Chair

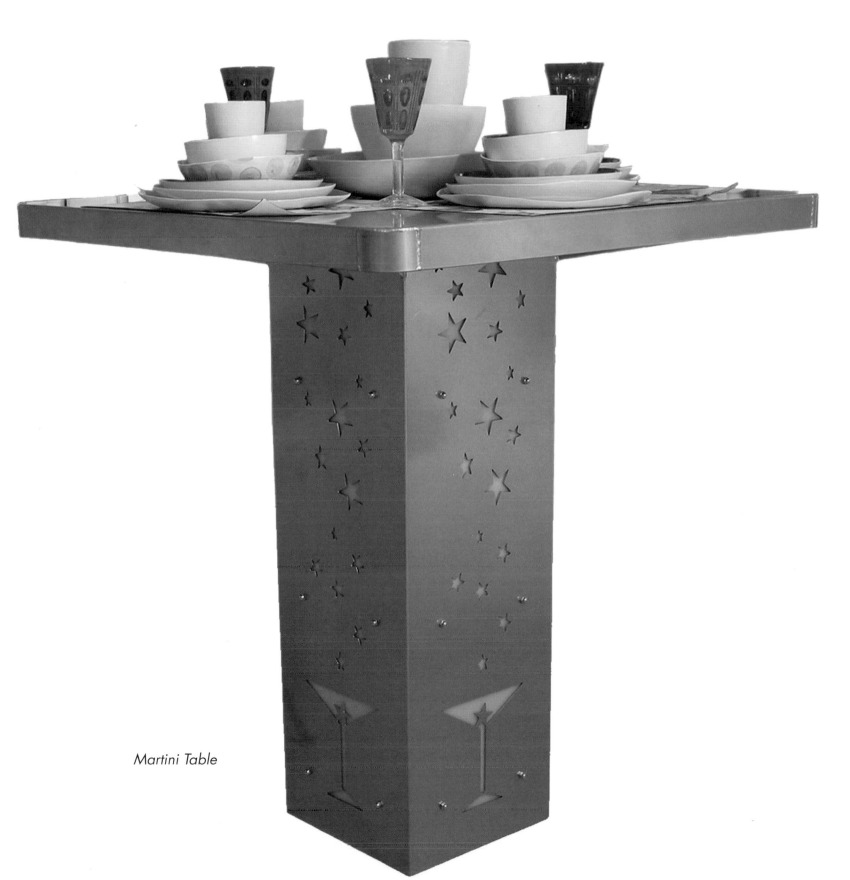

Martini Table

Abbi's Song

Dale continued to add new designs to his line in an effort to appeal to a wider audience at shows. He also began designing larger sculptures that incorporated rocks. The look of the stone against the metal was pleasing to Dale and gave his pieces a more organic feel.

In September 2003, Dale was scheduled to exhibit his work at a Gentlemen's Club Expo in Las Vegas. Buyer demographics in mind, Dale figured Vegas would be a good spot to show his Vargas-style nudes. In a clever move, Dale contacted the top four gentlemen's clubs in the area before the trip to inquire if he could show them some custom samples of his work, showcasing the names of their businesses.

Once in Vegas, he prominently displayed these samples in his booth. The smaller clubs then flocked to Dale's booth, and, wanting to be like the "big guys," started purchasing his work. Vegas turned out to be Dale's first successful show, but the atmosphere was such that he knew he would never return. Between Vegas and the woman who told Dale that his work was pornographic, the "huge, metal, naked chicks" were soon abandoned.

From Las Vegas, Dale continued on to Palm Desert to visit a gallery that had expressed interest in his work. Arriving at the appointed time, he found the gallery closed and was unable to reach the owners

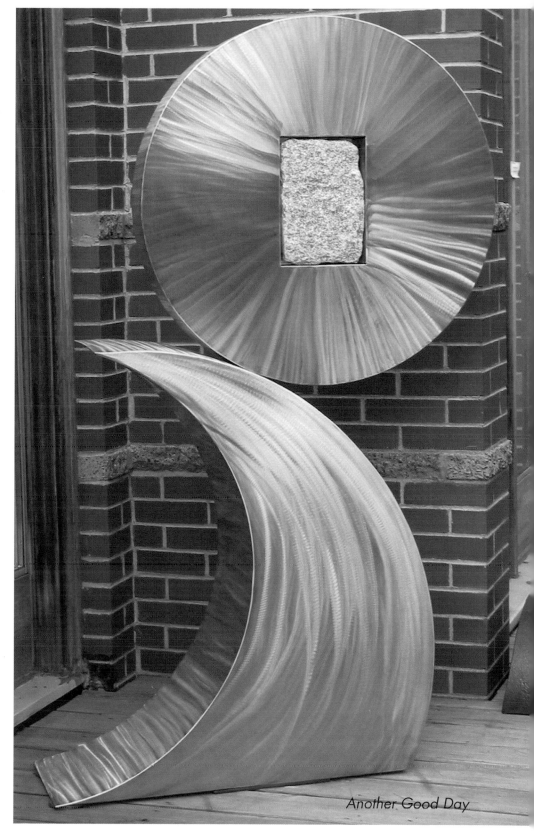

Another Good Day

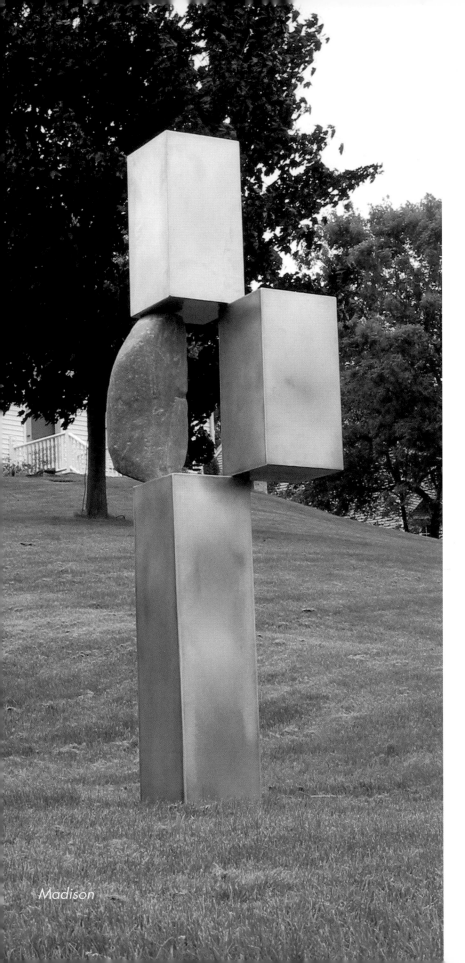

Madison

with whom he'd made plans. "I really did not want to drive all the way back east with my work still in the trailer. I drove around until I found the first gallery that was open. I went in, introduced myself, and asked if they would like to look at my work," recalls Dale.

Barbara, the manager of CODA Gallery, assessed his sculptures and liked *Another Good Day*. She agreed to take Dale's work, but only if he could get his pieces up to the second floor of the gallery. "I'm still not quite sure if she agreed because she never thought I would get them up there or if she really wanted them!" Fortunately, it was the beginning of a long-term relationship.

Dale muscled the pieces up to the second floor—most weighed over 200 pounds—and positioned them where she requested. CODA owners David and Connie Katz were among the early supporters of Dale's work and played a pivotal role in establishing Dale as an American sculpture artist.

One month later, in October 2003, Dale met another pair of mentors, this time with Paradise City Arts Festival across New England. Jeff and Linda Post, founders of the show, worked with Dale to improve his booth displays, develop sales techniques, and adjust his pricing.

In these early years, Dale faced struggles familiar to artists across many mediums: how to keep his work affordable in a tough economy; how to address the logistics of shipping one-of-a-kind pieces; and how to balance his own artistic desires with those of his clients.

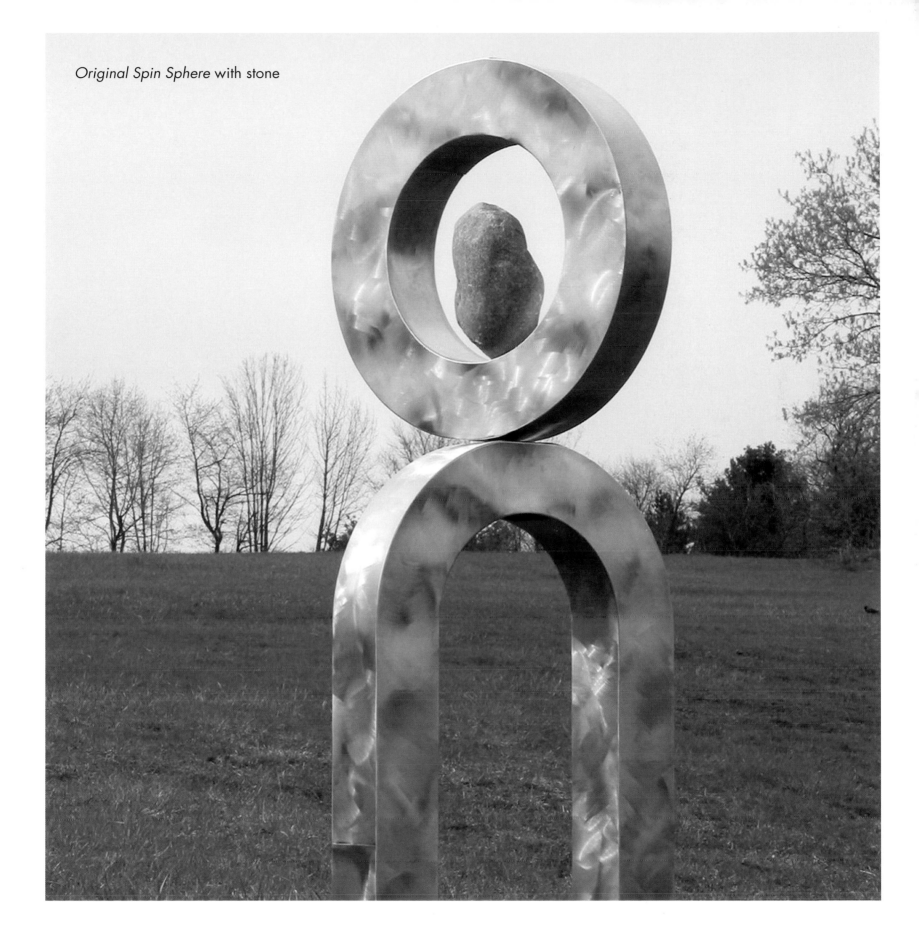

Original Spin Sphere with stone

The Evolution of "Team Rogers"

In 2004, Dale's art really started to take on the style he is well known for today. He intentionally began to design his sculptures to be iconic, allowing people to connect with them on an emotional level. Dale also began working with a new medium, Cor-Ten steel, which he chose for its durability and low maintenance. *Lola's Dress* and *American Dog* are his first examples of iconic sculptures created with Cor-Ten steel.

Dale's love for abstract geometrics is also represented in his design aesthetic, which often reflects the Googie style of architecture and art, popular in the 1940s and 1950s. The Googie style was deliberately flashy and used futuristic angles, rounded corners, and overlapping pieces. This mode of expression appears in many of Dale's pieces, including *3 Cubes* and *Retro Trees*. *Bea Gong* and *Rise* both incorporate futuristic angles. The latter is especially

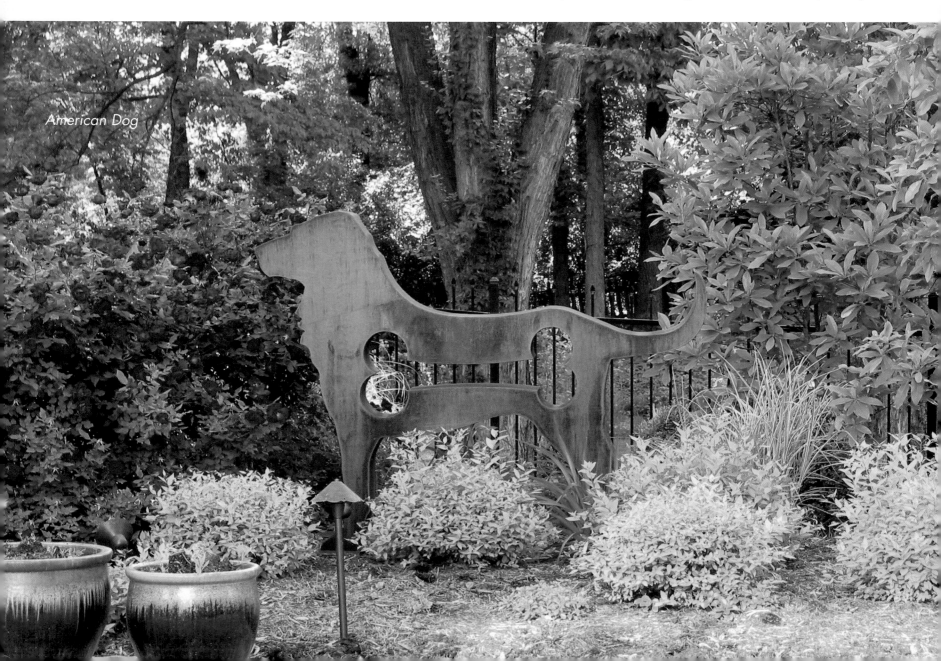

American Dog

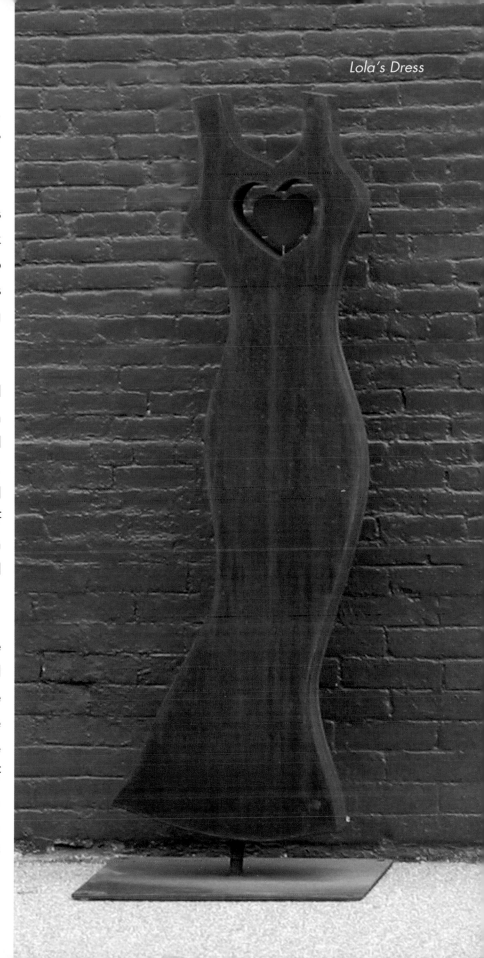

interesting, as it is wider at the top when viewed straight on, but if viewed from the side, the sculpture appears to narrow at its peak.

As Dale defined his style, he found that translating his ideas into 3-D sculptures was both complex and daunting. Mark Semler, an engineer and good friend, introduced Dale to 3-D software and taught him how to use it to design his sculptures. It is technically challenging but critical to creating accurate pieces and minimizing metal waste.

In 2006, Dale began to integrate inspirational poems and quotes in his sculptures, creating an even deeper connection to his art. *Raven* was the first piece in which he incorporated verse, laser cutting a poem by Edgar Allan Poe into the steel. In 2008, Dale began combining Cor-Ten and Stainless steel to add depth and contrast to his work. The bright sheen of the Stainless against the more organic, oxidized Cor-Ten was an instant winner, as demonstrated in *Bea Girl* and *Distant Beauty*.

Meanwhile, Dale was adjusting to the demands of life on the road and selling his work at shows. He expanded beyond the New England area, which allowed him to increase his client base, work with more galleries, and participate in larger show productions throughout the country. He especially enjoyed the shows produced by Amy Amdur, of Amdur Productions, based in Chicago, and Howard Alan, of Howard Alan Events and American Craft Endeavors, based in Florida. Dale was invited to have solo exhibitions

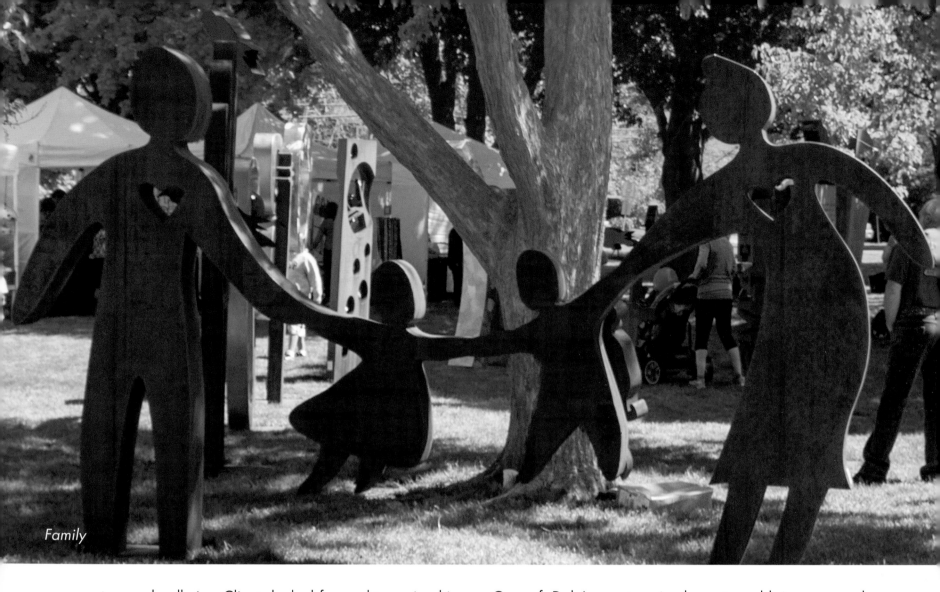

Family

at several galleries. Clients looked forward to seeing him whenever he was in their area. Amy says, "Dale is a unique artist in that he is able to simplify the human experience into the essence of a moment. He creates pieces that people relate to and are drawn to. The viewer becomes captivated by his work."

As the Dale Rogers Studio brand became more recognizable and Dale continued to introduce more designs and expand his line, he realized it was time to expand beyond a one-man shop.

One of Dale's mentors in the art world is renowned glass sculptor Dale Chihuly. He is a favorite not just for his incredible glass works but for his business acumen as well. Dale connected with and admired Chihuly's team approach, and he set out to develop a crew of his own.

The studio is still based in Dale's garage and basement, where it started, however, he now has help in both the office and the shop. A full-time welder was hired in 2006 to help Dale fulfill his show orders and to free up the time he needed to design new sculptures. He also decided to

have his metal laser cut due to the accuracy of the laser and now uses Salem Metal Fabricators, owned by Jason Vining. The tighter tolerances achieved with this machine allow Dale to attain higher standards in the overall design and improved quality in his sculptures.

In 2008, Dale hired Allisa Rudden to help manage the office, inventory and orders. She is well known by all of Dale's clients and helps keep the studio running smoothly.

And in 2011, I was hired to manage Dale's websites and develop graphic materials and marketing pieces.

By initiating a team approach, Dale has cultivated a culture of dedication and mutual support in his studio. It is his staff, which he dubbed "Team Rogers," that allows him to continue making art in the studio and to expand into public art and exhibitions.

chapter 4
Sculpture Gallery

Another Good Day

2004 • Stainless Steel • Glass Block • 70"h x 43"w x 33"d

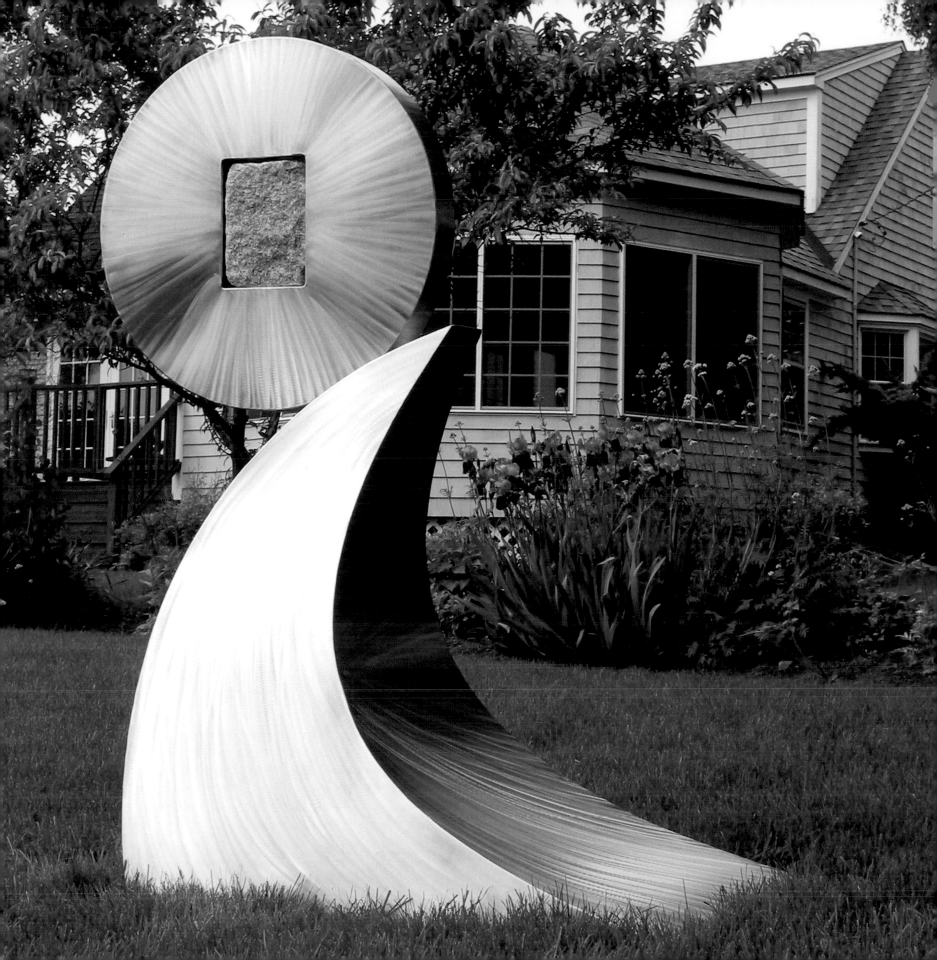

Joy

2004 • Stainless Steel • Glass Block • 69"h x 23"w x 11"d

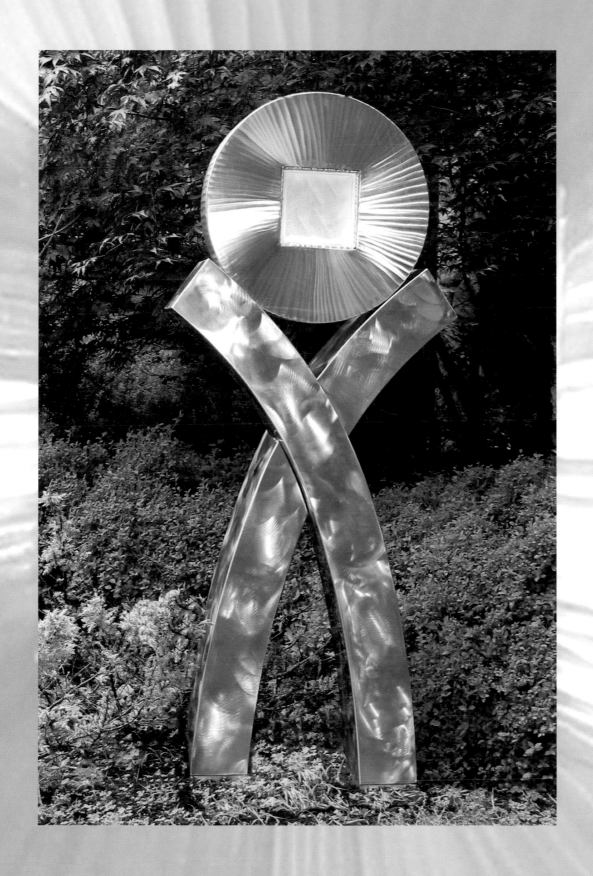

American Dog

2004 (2011 Version Pictured) • Cor-Ten Steel • 55"h x 74"w x 8"d • 72"h x 96"w x 8"d

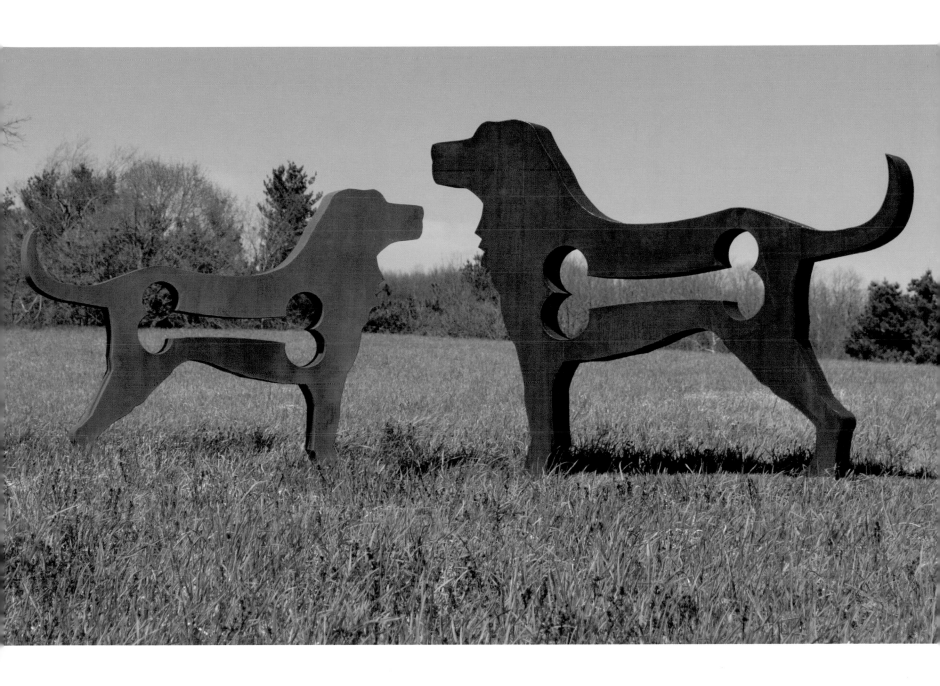

Trapped Ball

2004 • Stainless Steel • Oxidized Steel Ball with Penetrol Finish • 76"h x 23"w x 27"d

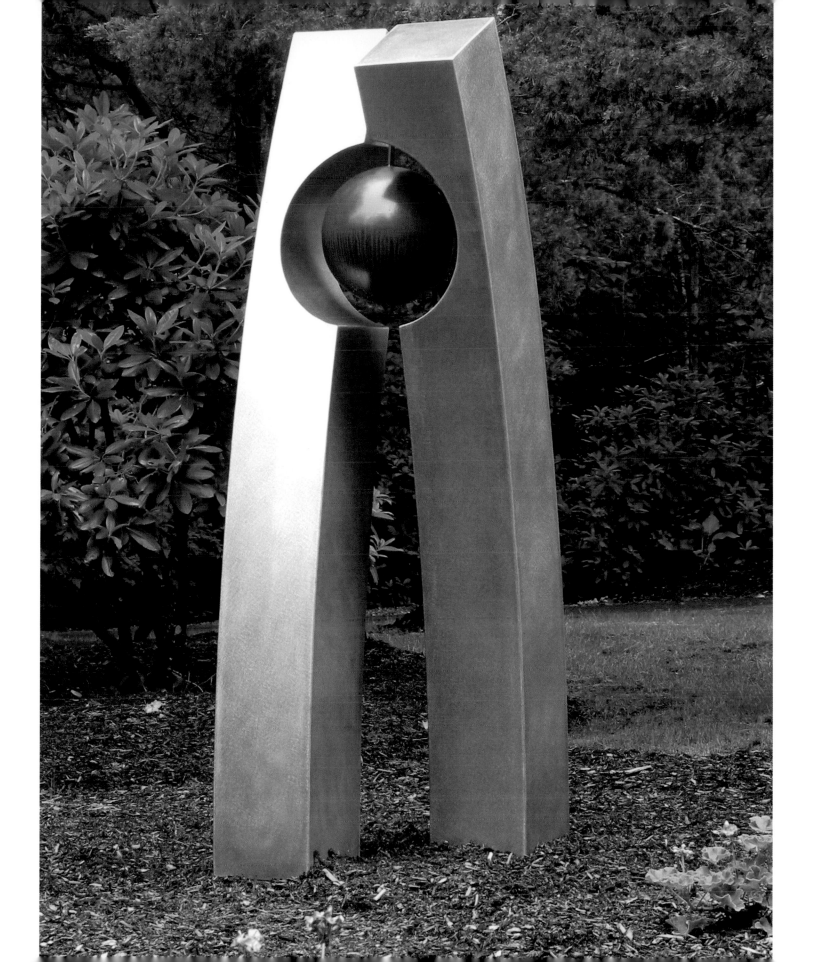

Ball Tower

2004 • Stainless Steel • Oxidized Steel Ball with Penetrol Finish • 70"h x 27"w x 23"d

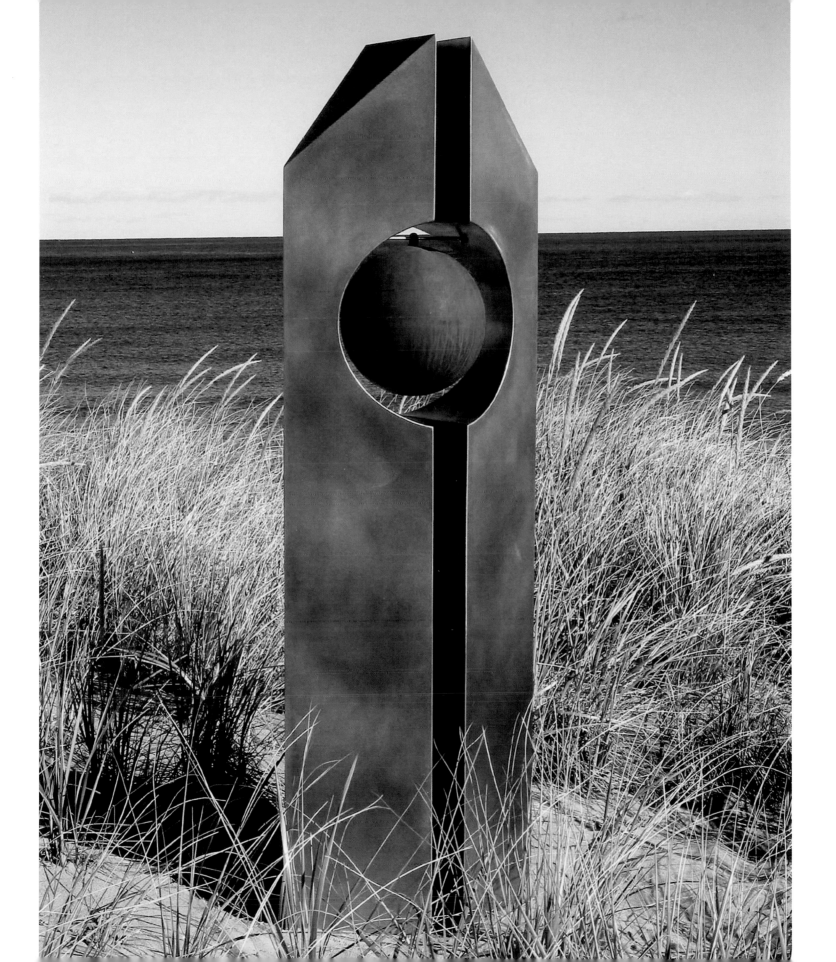

Lola's Dress

2005 • Cor-Ten Steel • 62"h x 28"w x 6"d

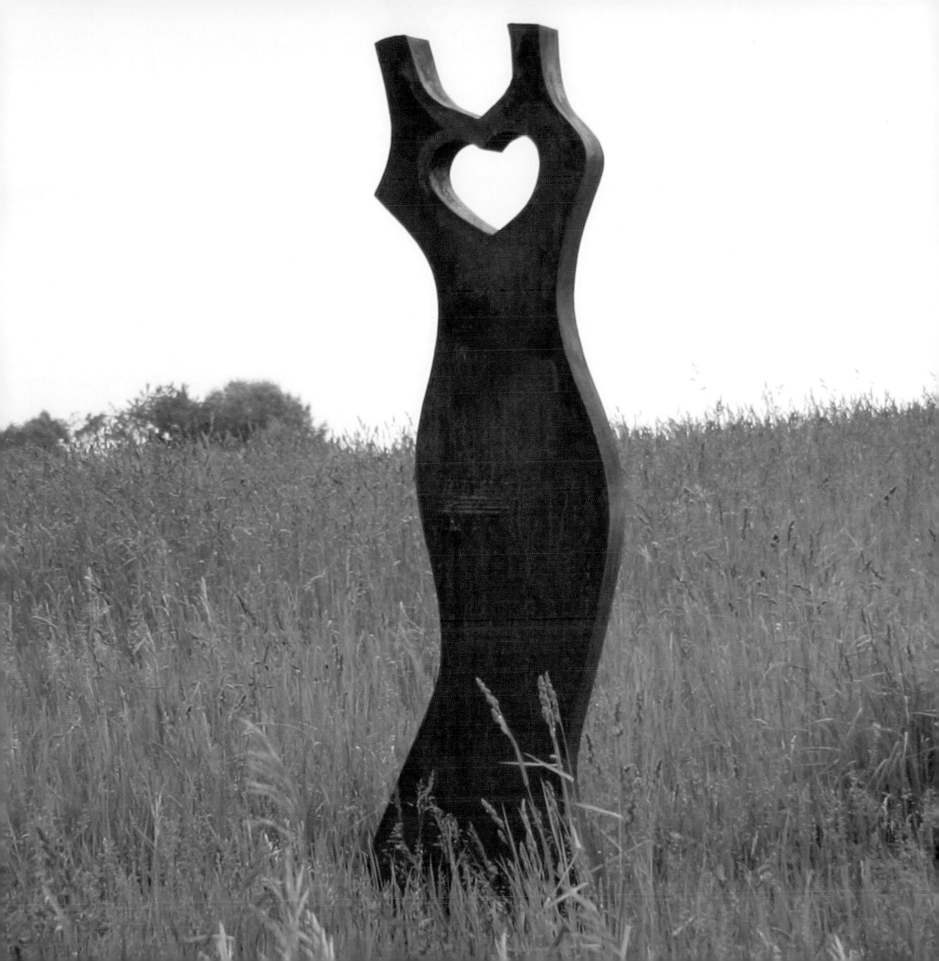

Star Tower

2005 • Stainless Steel • Oxidized Steel Ball with Penetrol Finish • 70"h x 32"w x 23"d

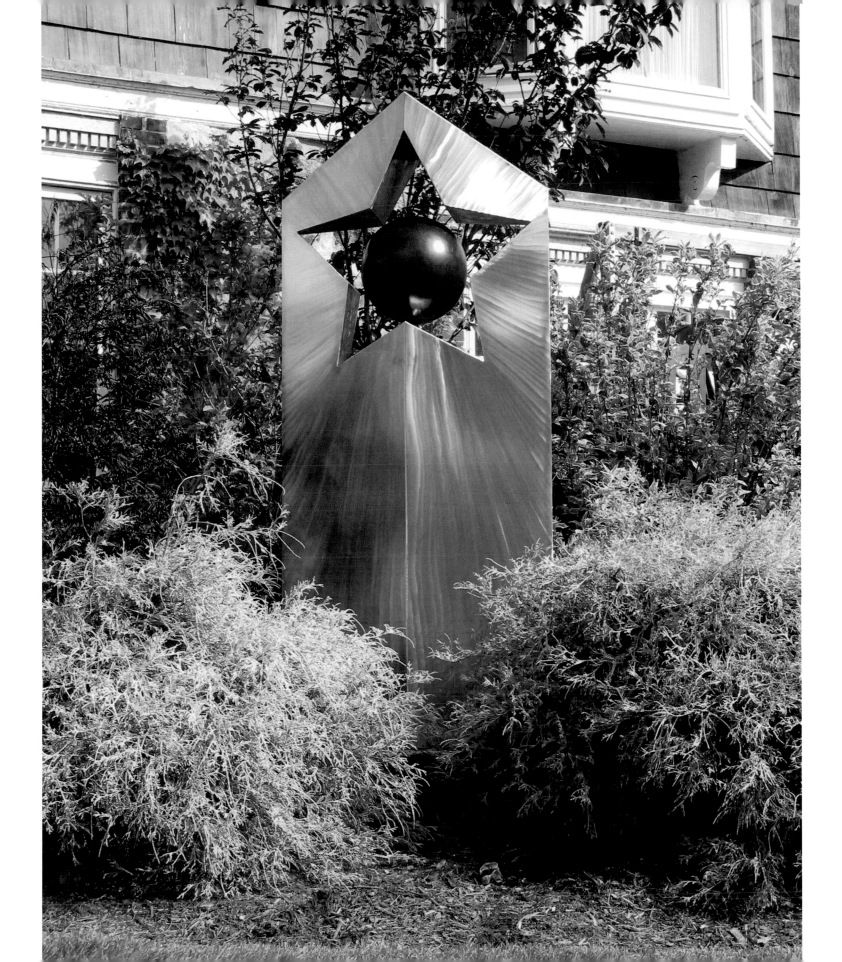

2 Farmers

2006 • Cor-Ten Steel • Painted Steel Ball • Stainless Steel Insert • 50"h x 40"w x 23"d

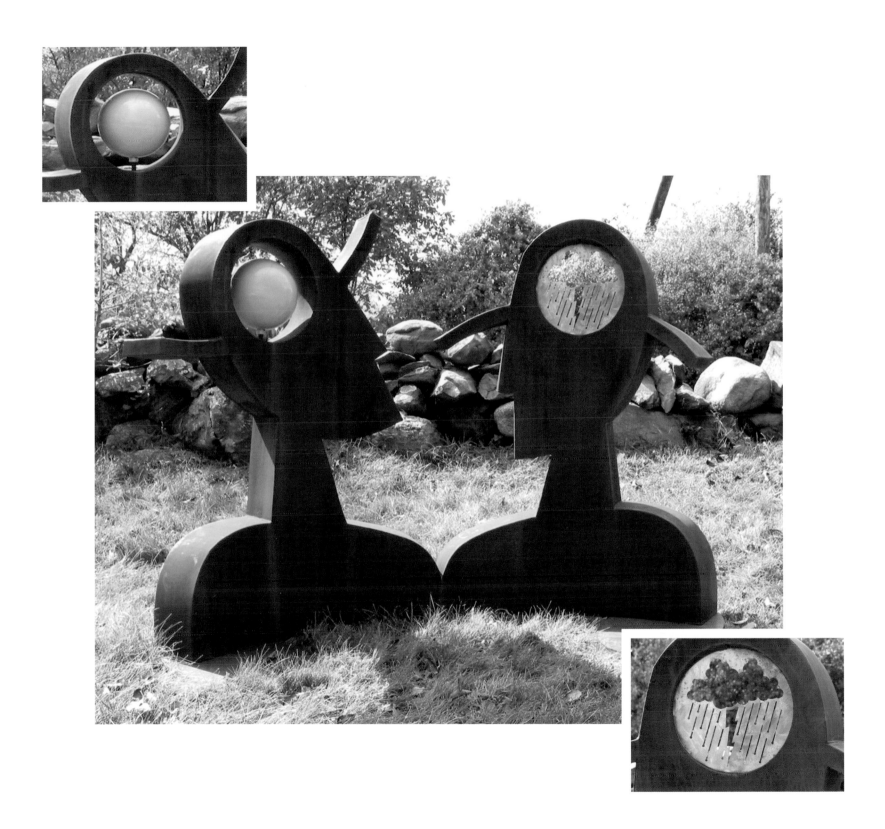

Bea Gong

2006 • Cor-Ten Steel • Gong • 80"h x 48"w x 40"d

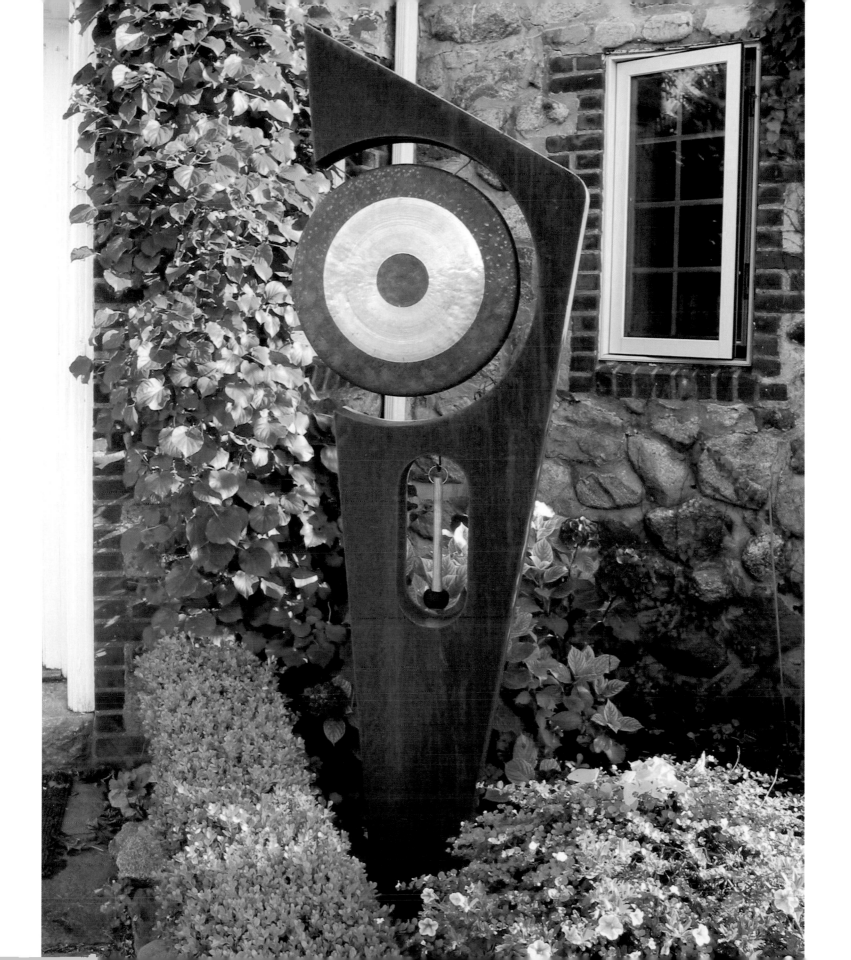

Raven

2006 • Cor-Ten Steel • Painted Steel Raven • 82"h x 23"w x 6"d

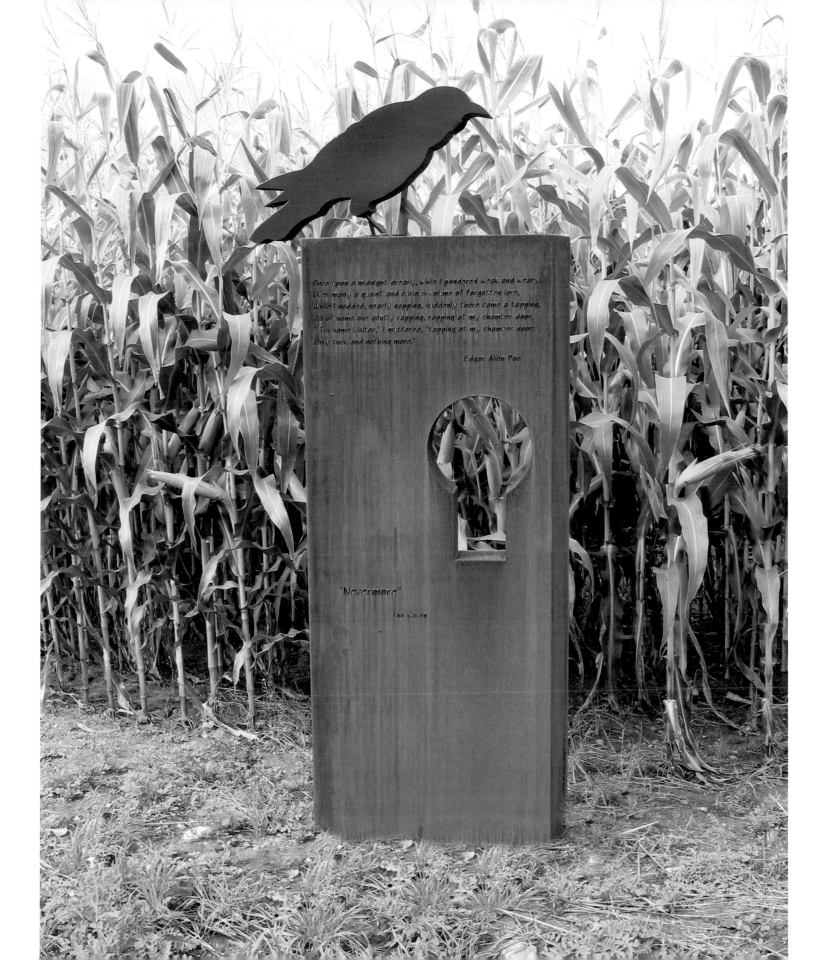

Duet

2006 • Stainless Steel • 85"h x 46"w x 8"d

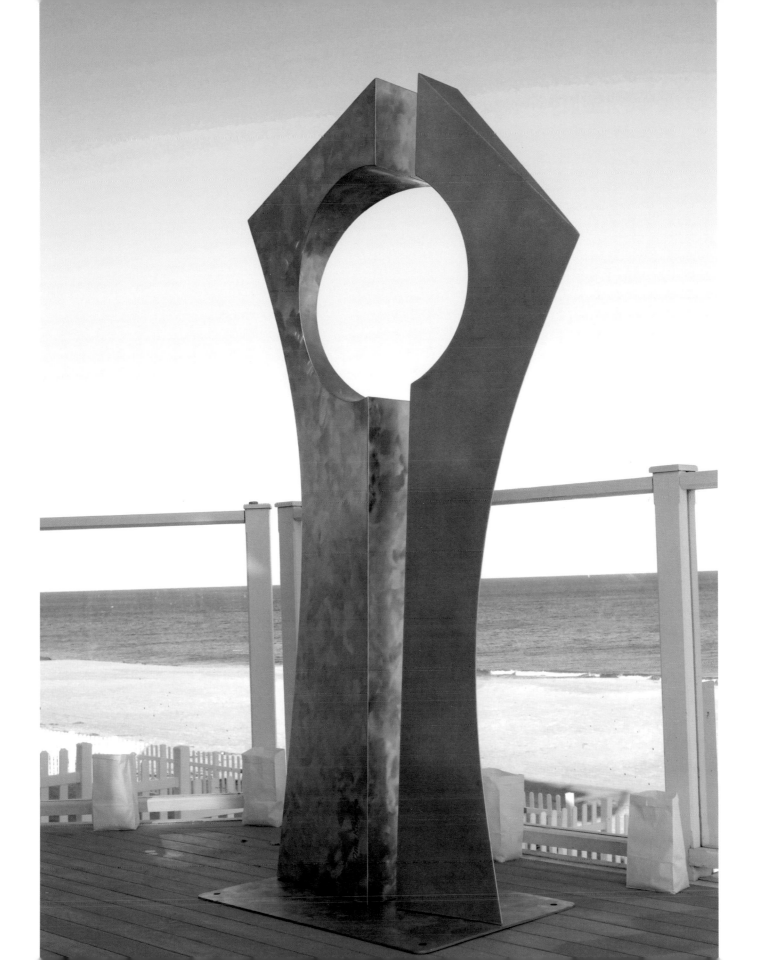

3 Cubes

2007 • Stainless Steel • Painted Steel Ball • 78"h x 54"w x 14"d

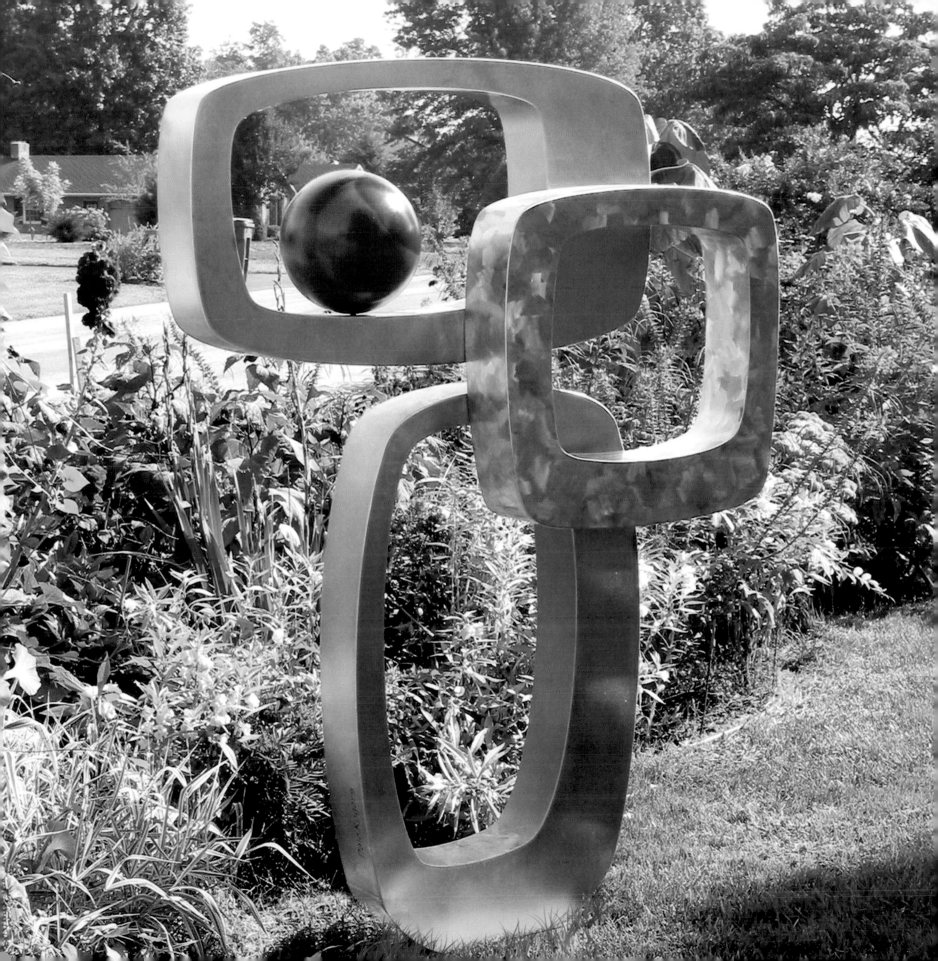

Rise

2007 • Cor-Ten Steel • Painted Steel Ball • 79"h x 32"w x 273"d

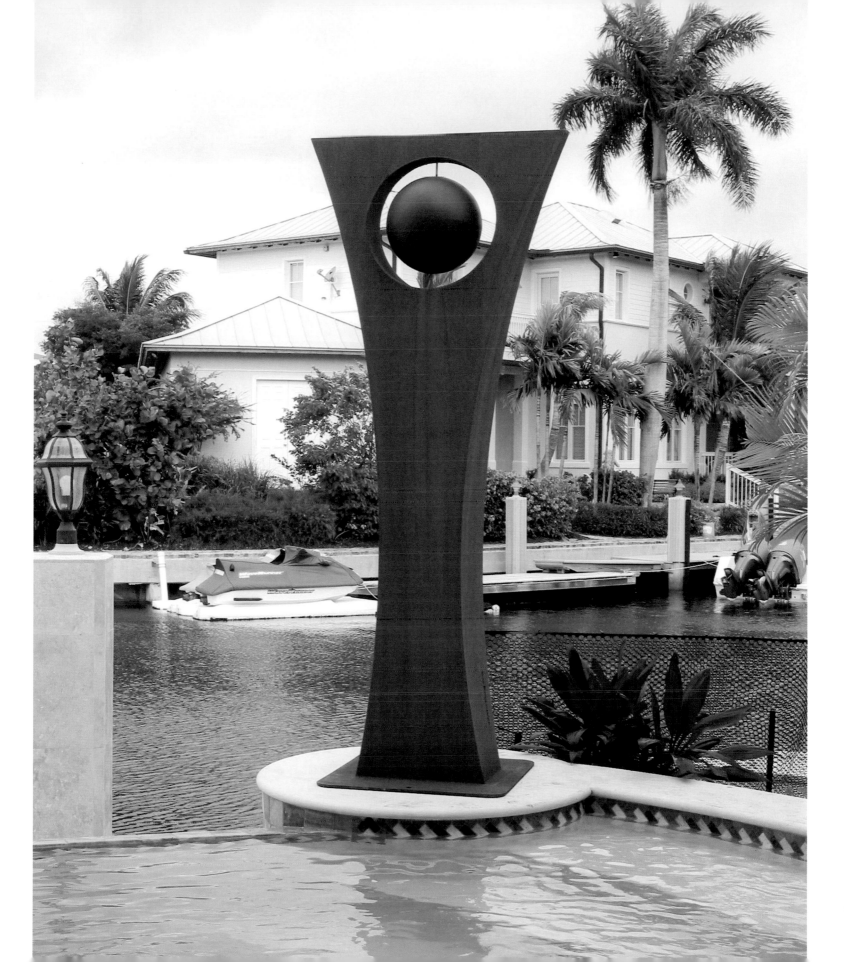

Exclaim

2007 • Stainless Steel • 82"h x 32"w x 18"d

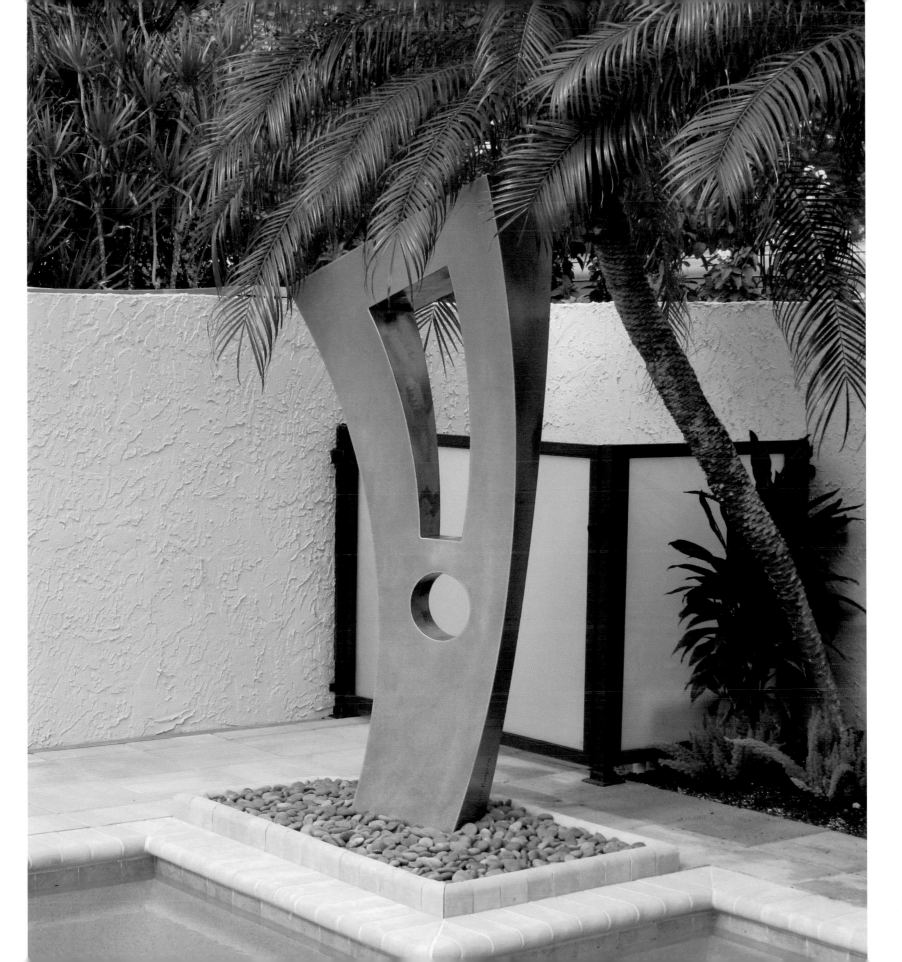

G Swirl

2007 • Stainless Steel • 93"h x 30"w x 32"d

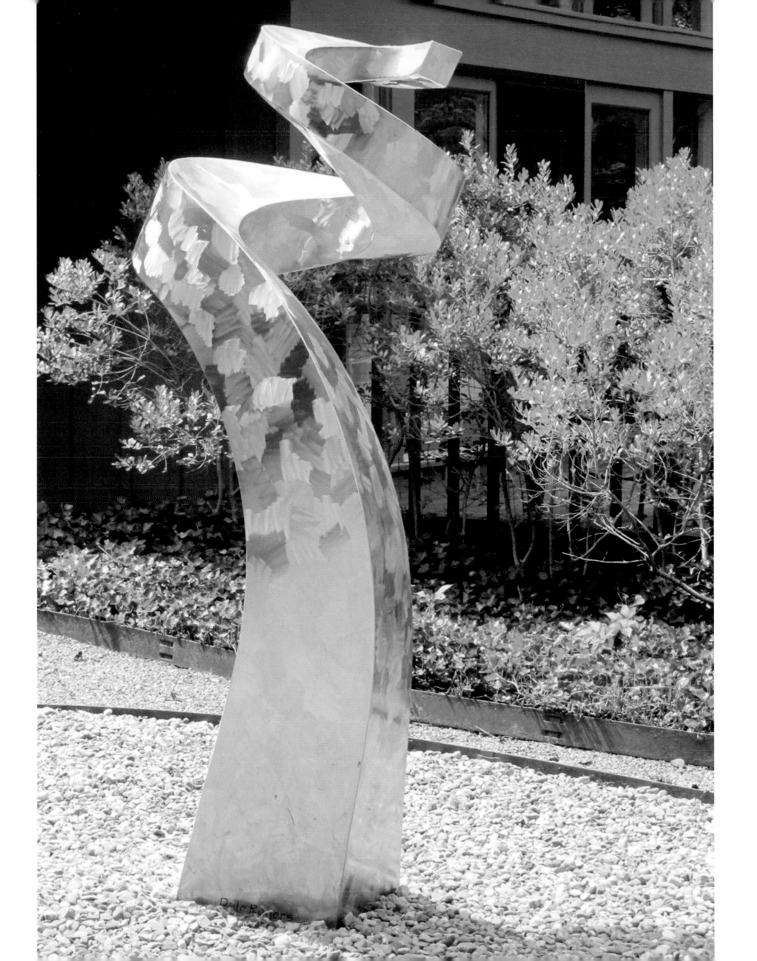

Hands

2007 • Cor-Ten Steel • 83"h x 23"w x 6"d

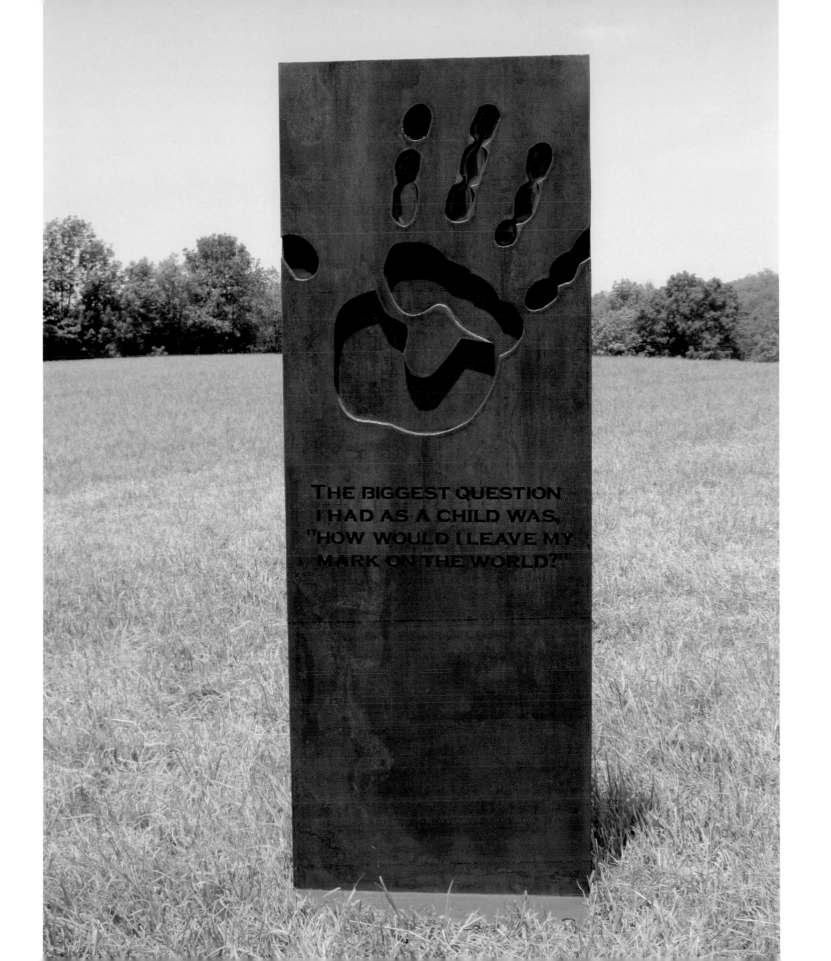

2 Roads

2008 • Cor-Ten Steel • 78"h x 35"w x 23"d

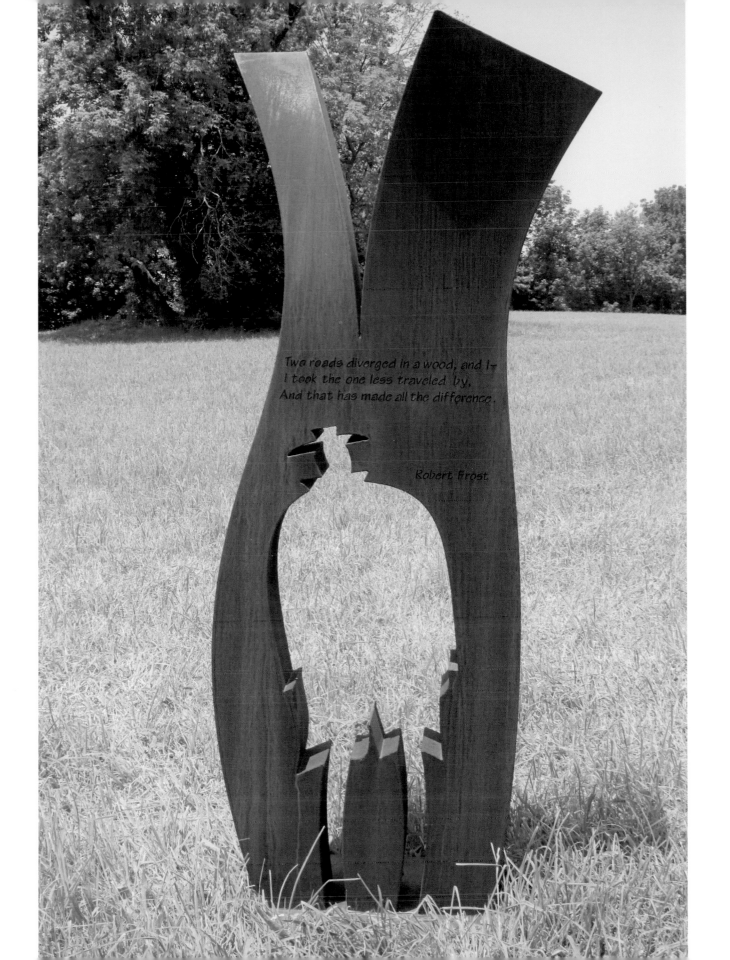

Two roads diverged in a wood, and I—
I took the one less traveled by,
And that has made all the difference.

Robert Frost

Crow Key

2008 • Cor-Ten Steel • Painted Steel Crow • 67"h x 36"w x 29"d

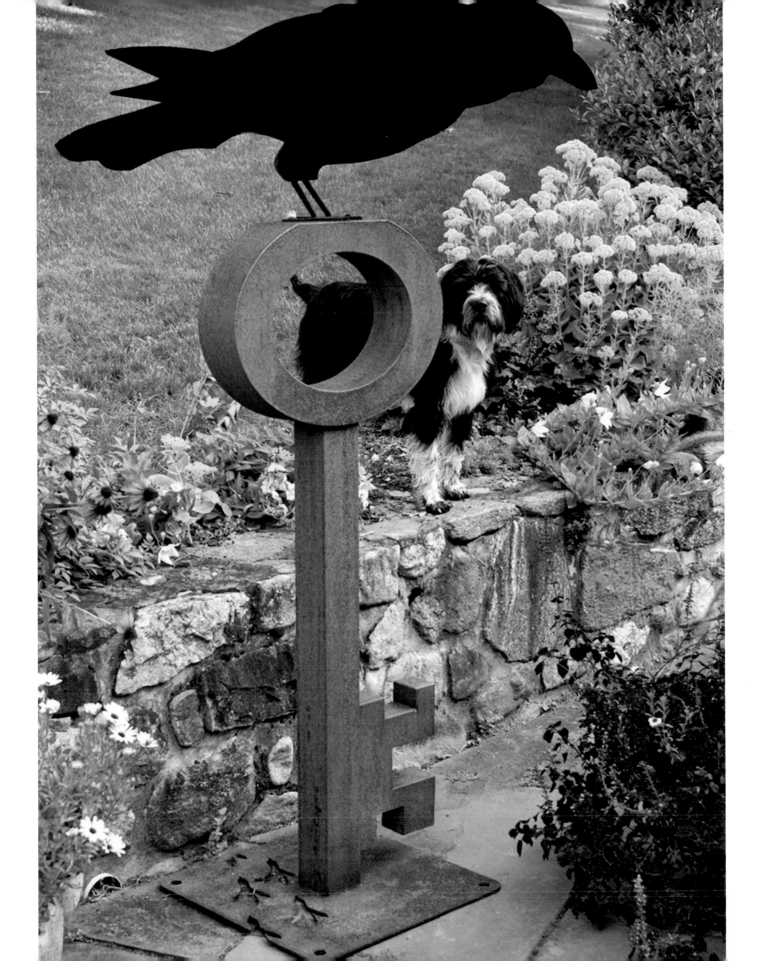

Guitar

2008 • Cor-Ten Steel • Stainless Steel Rods • 93"h x 36"w x 8"d

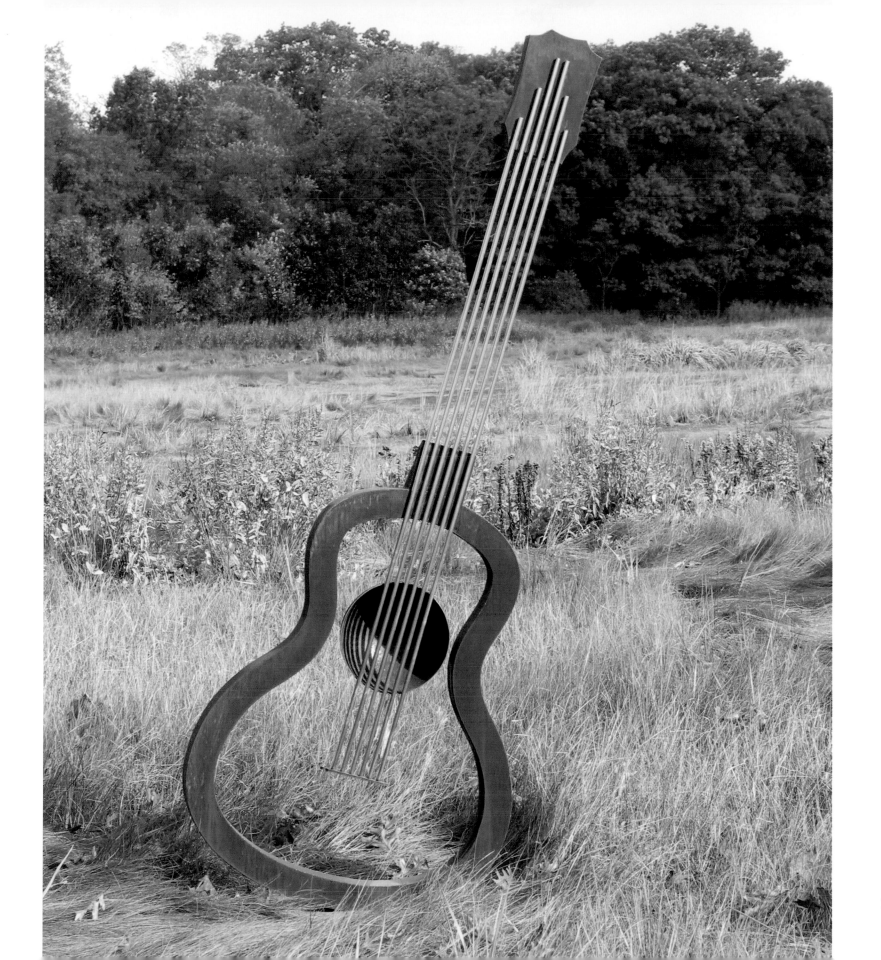

Olive Branch

2008 • Cor-Ten and Stainless Steel • Painted Steel Crow • 87"h x 48"w x 16"d

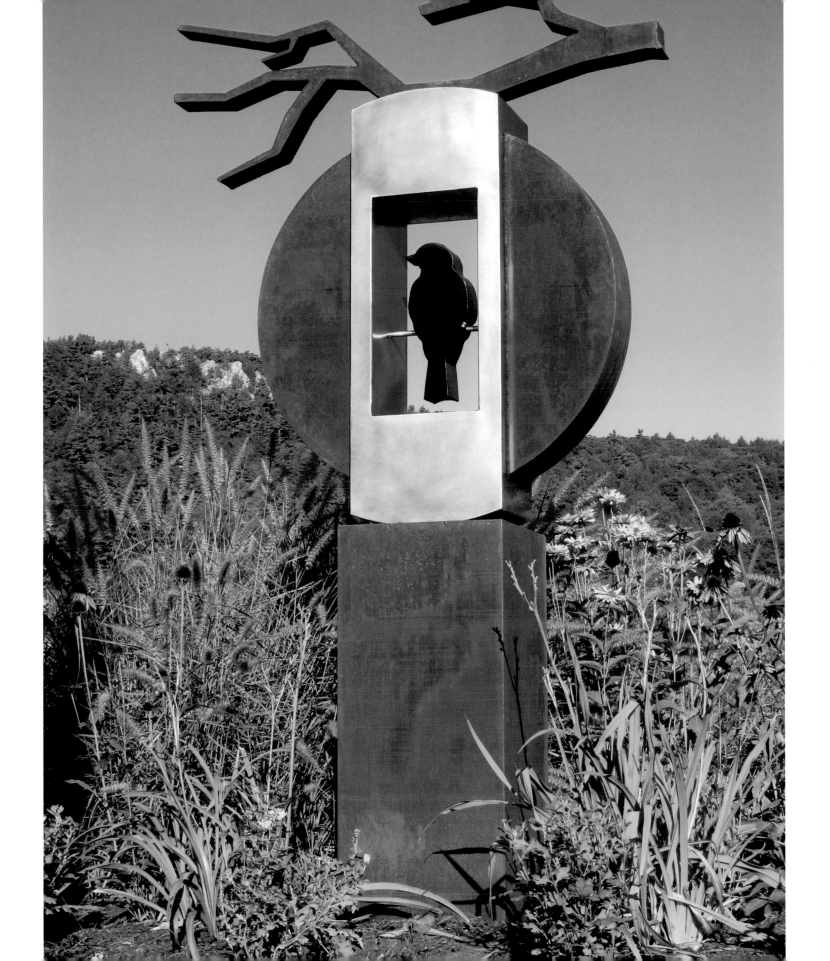

Easter Island Head

2008 • Cor-Ten Steel • 90"h x 40"w x 40"d

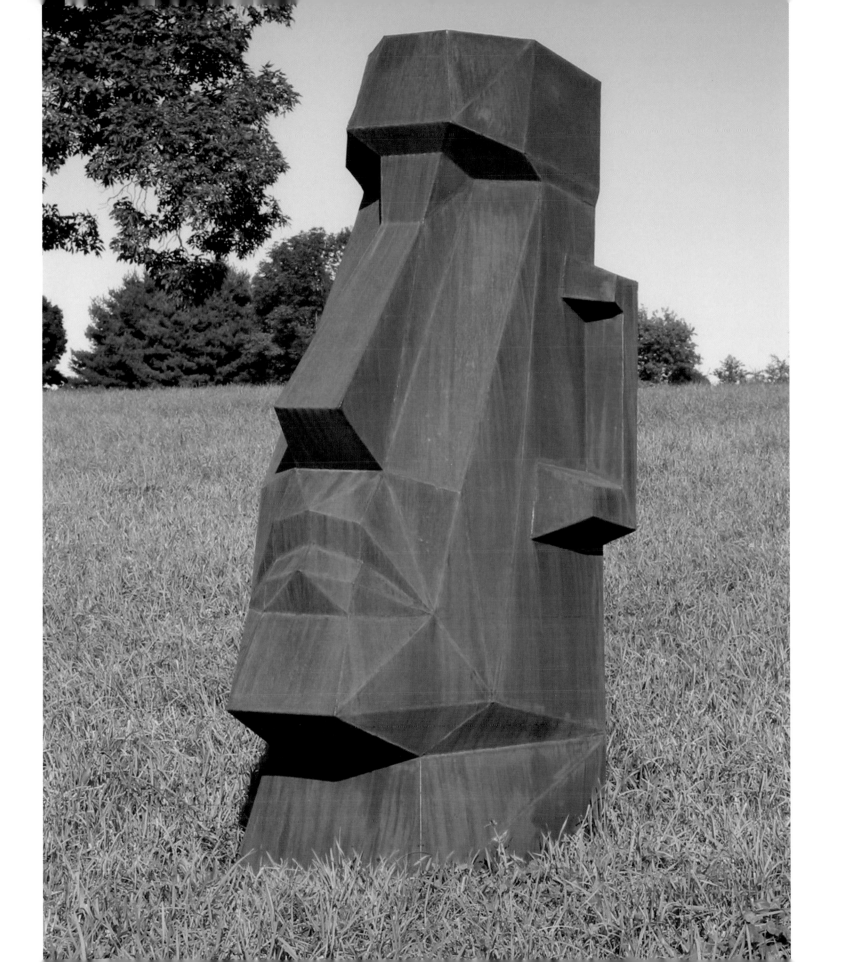

Distant Beauty

2008 • Cor-Ten Steel • Stainless Steel • 79"h x 31"w x 6"d

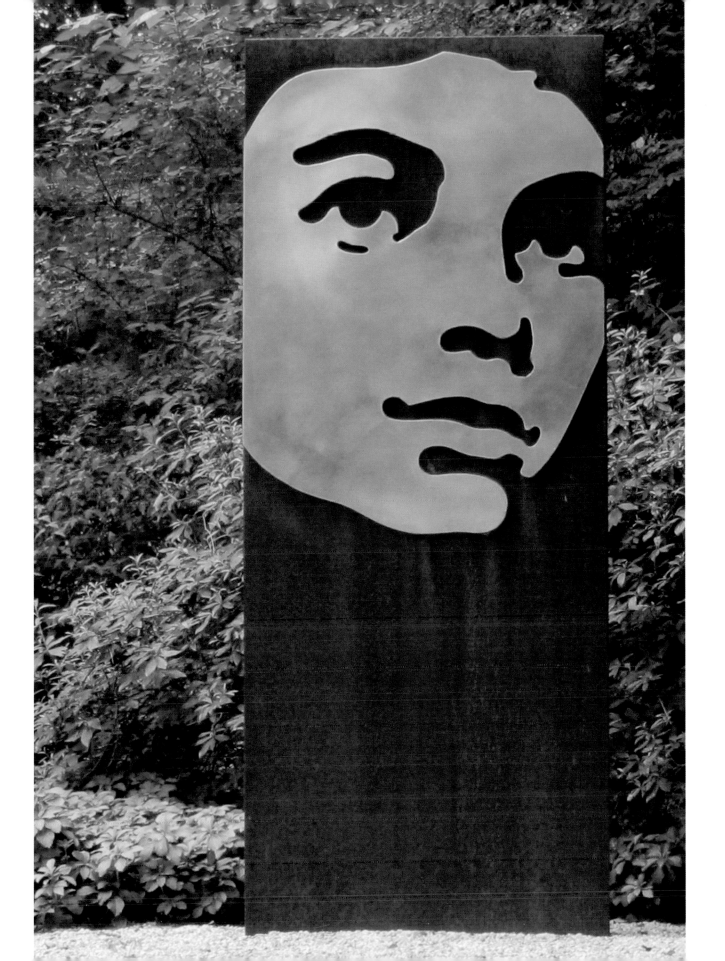

Shooting Stars

2008 • Stainless Steel • 80"h x 23"w x 23"d

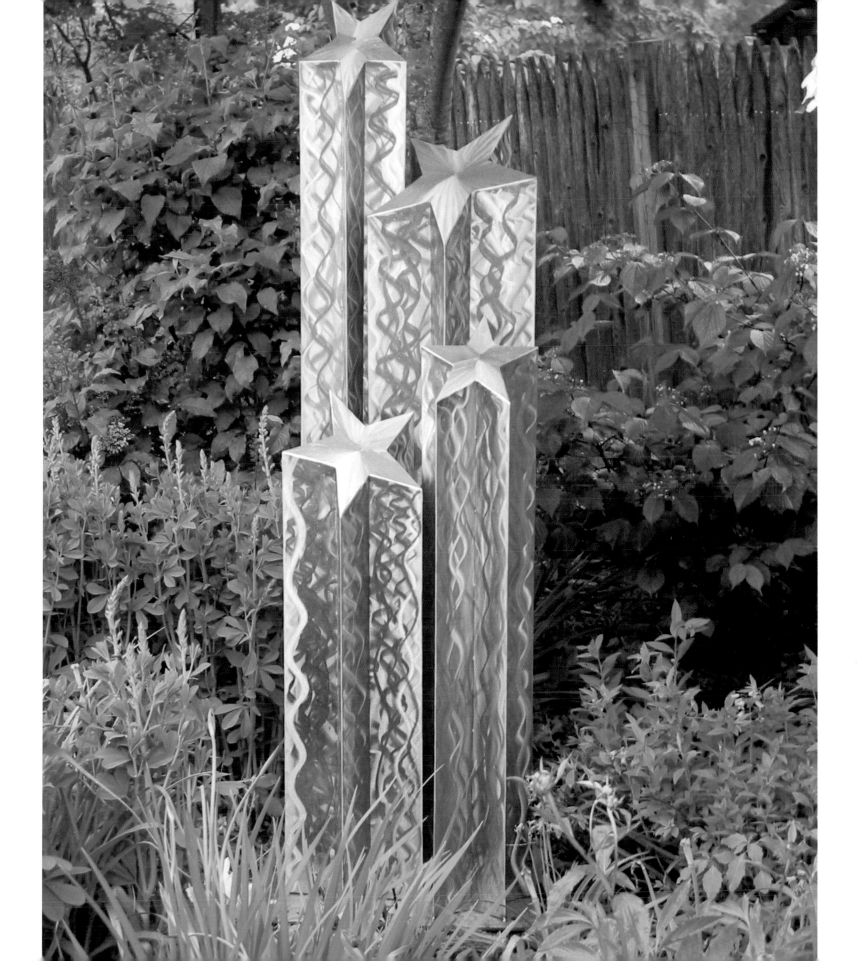

Roman Horse

2008 • Cor-Ten Steel • 77"h x 62"w x 8"d

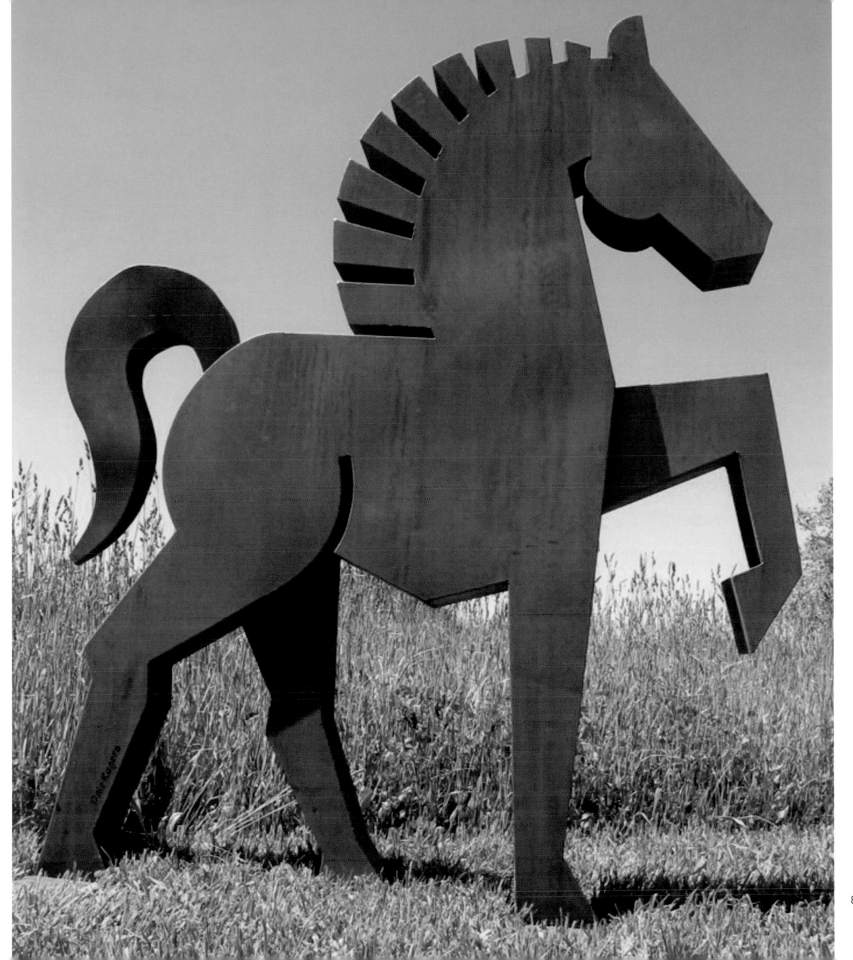

Believe

2009 • Cor-Ten Steel • 75"h x 23"w x 6"d

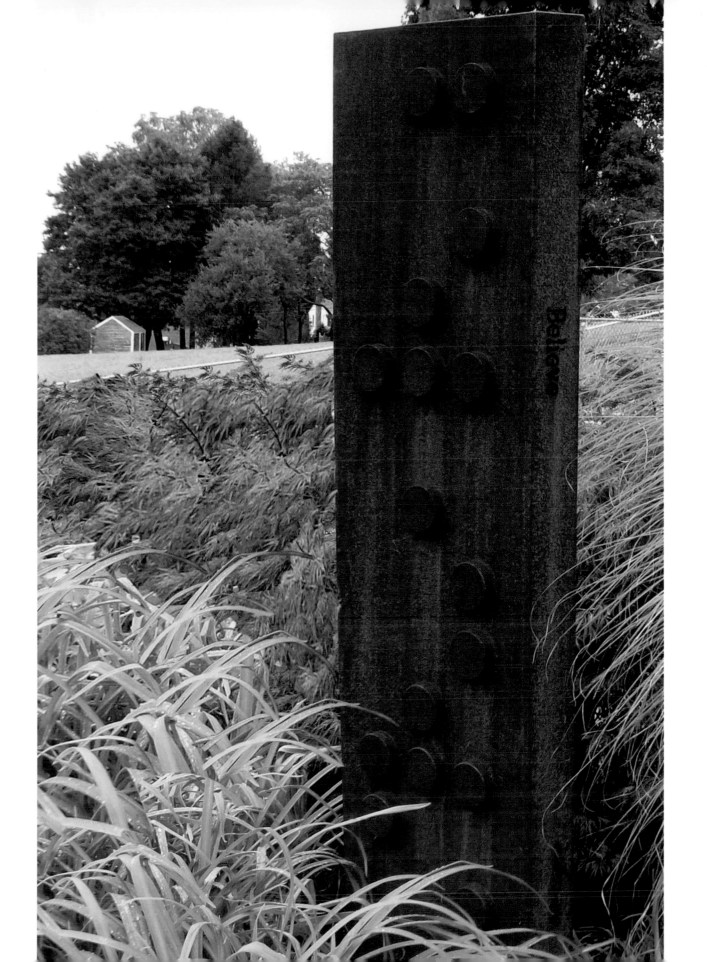

Dog & Cat

2009 • Cor-Ten Steel • 108"h x 96"w x 8"d

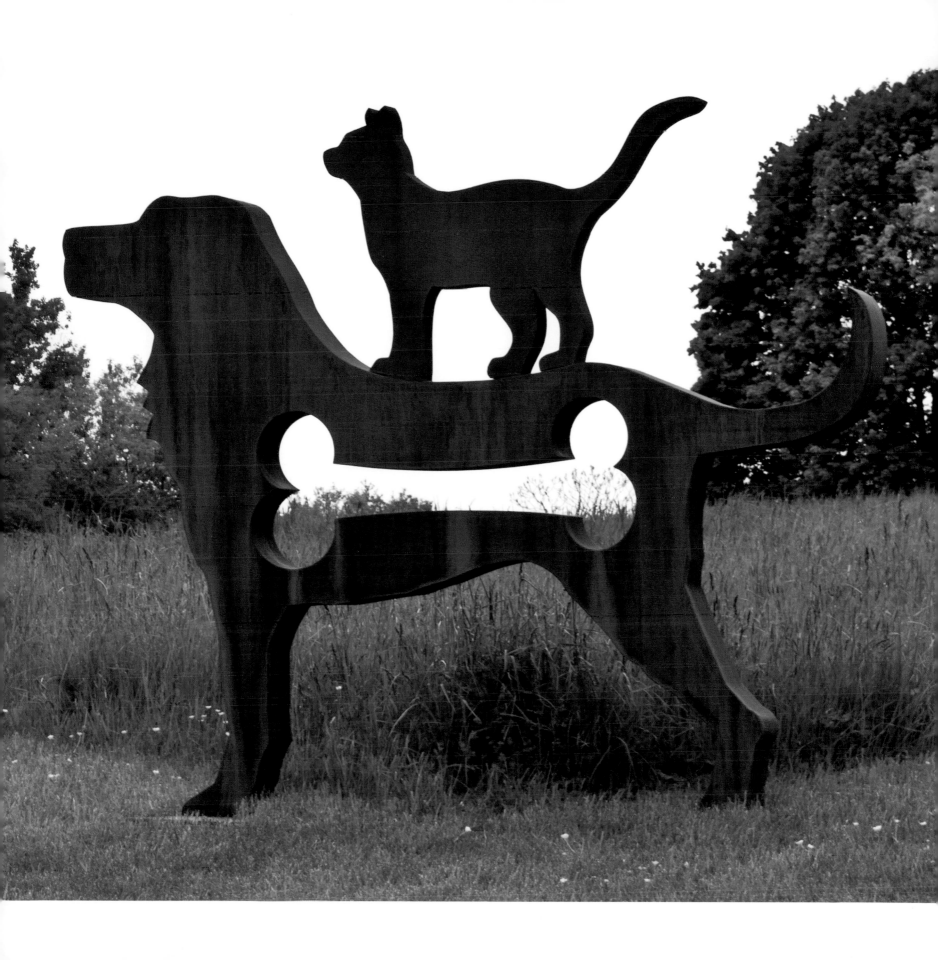

Lucky Dog

2009 • Cor-Ten Steel • 55"h x 74"w x 8"d

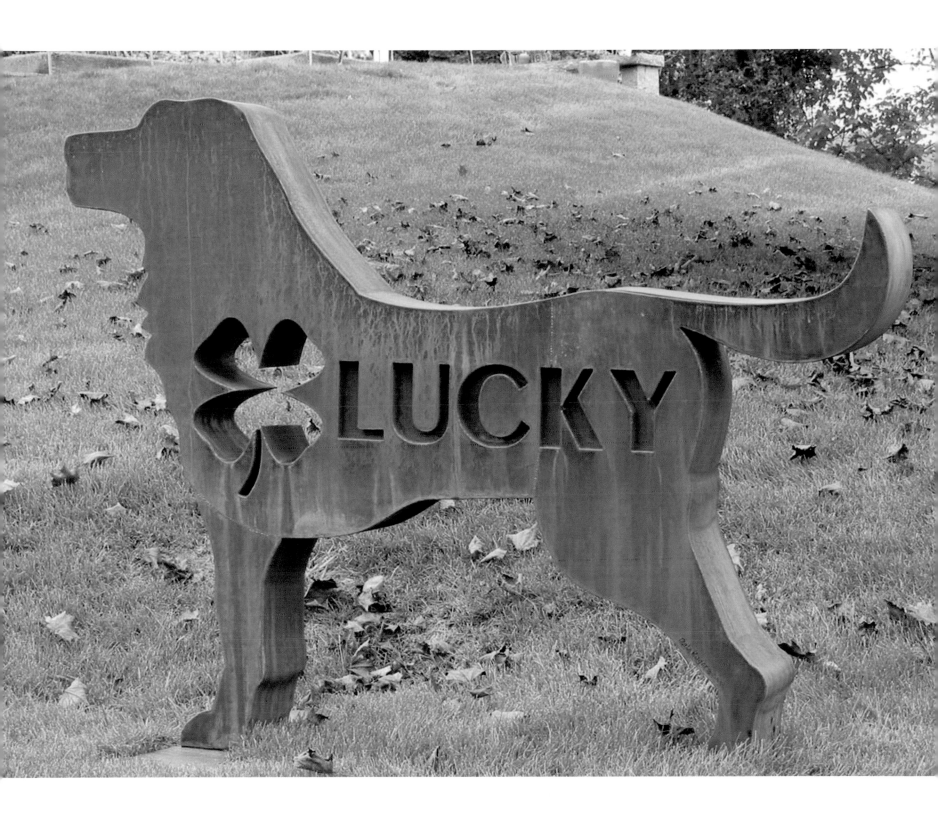

Shark

2009 • Stainless Steel • 70"h x 95"w x 34"d

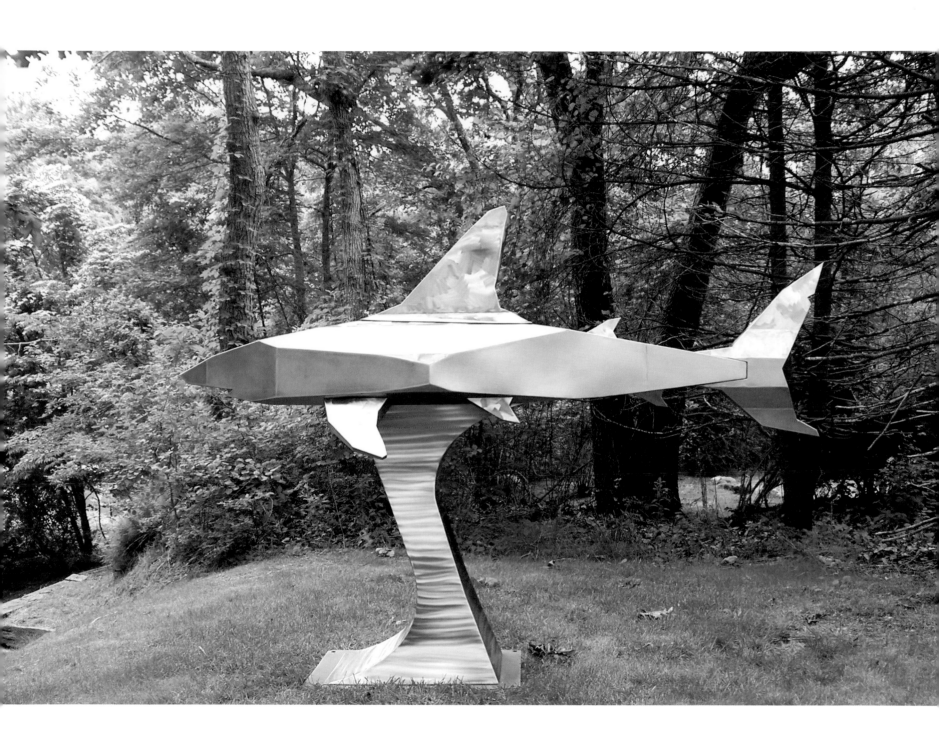

Bea Girl

2009 • Cor-Ten and Stainless Steel • 92"h x 36"w x 6"d

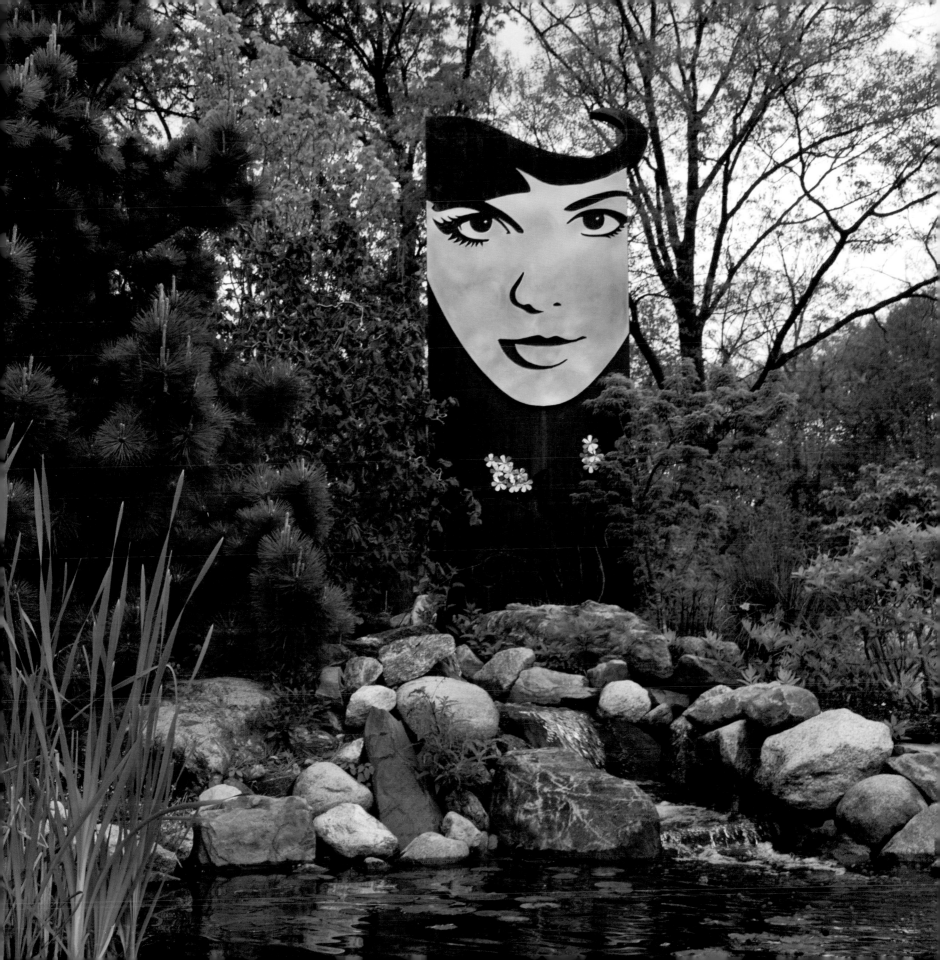

A Good Idea

2010 • Cor-Ten Steel • Painted Steel Ball • 78"h x 54"w x 18"d

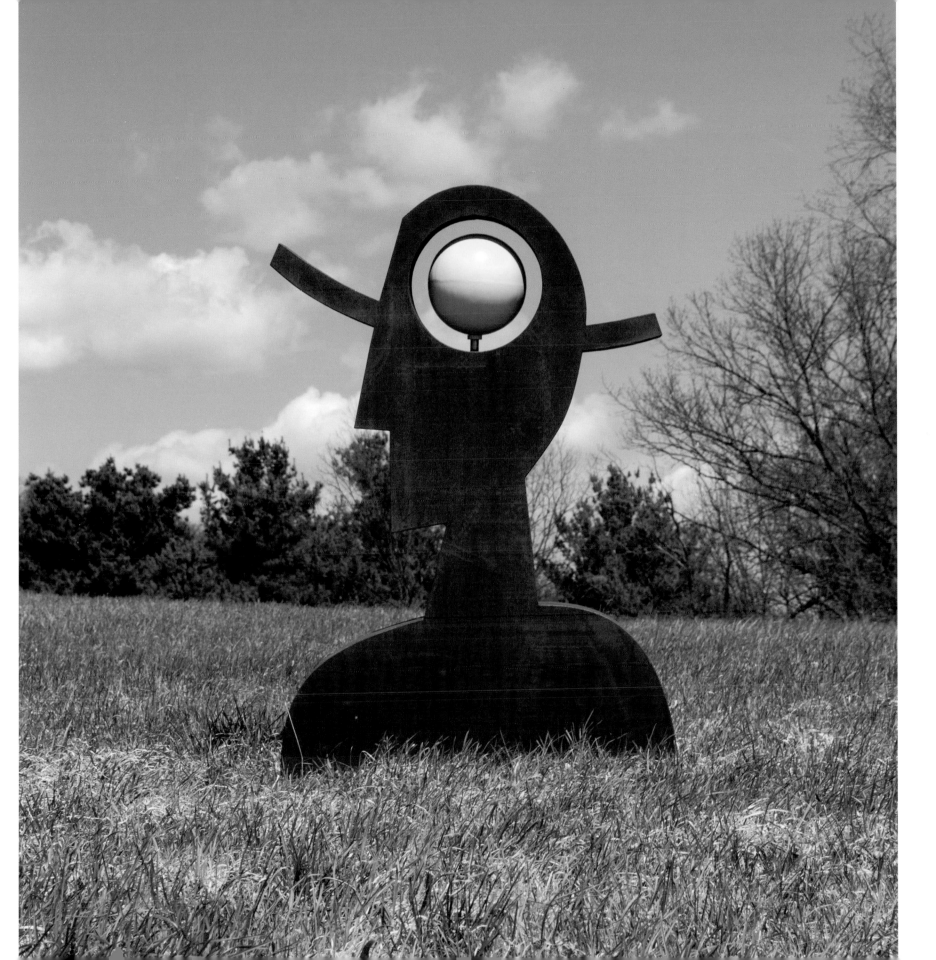

4 People

2010 • Cor-Ten Steel • 84"h x 180"w x 8"d

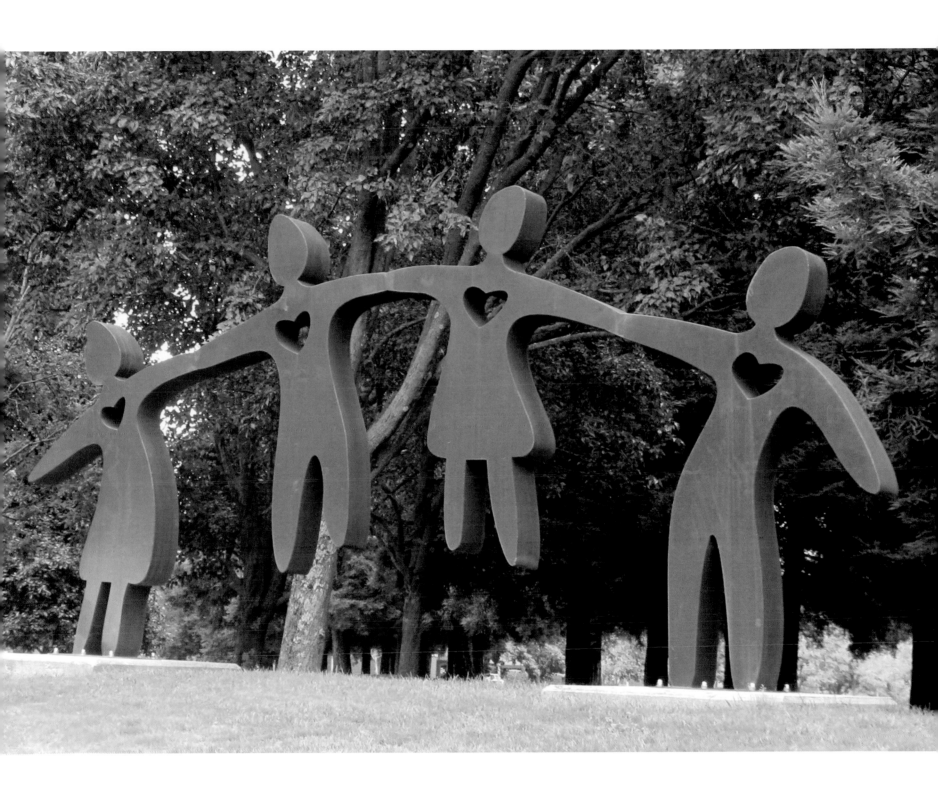

Retro Tree

2010 • Cor-Ten and Stainless Steel • Painted Steel Cardinal • 93"h x 54"w x 24"d

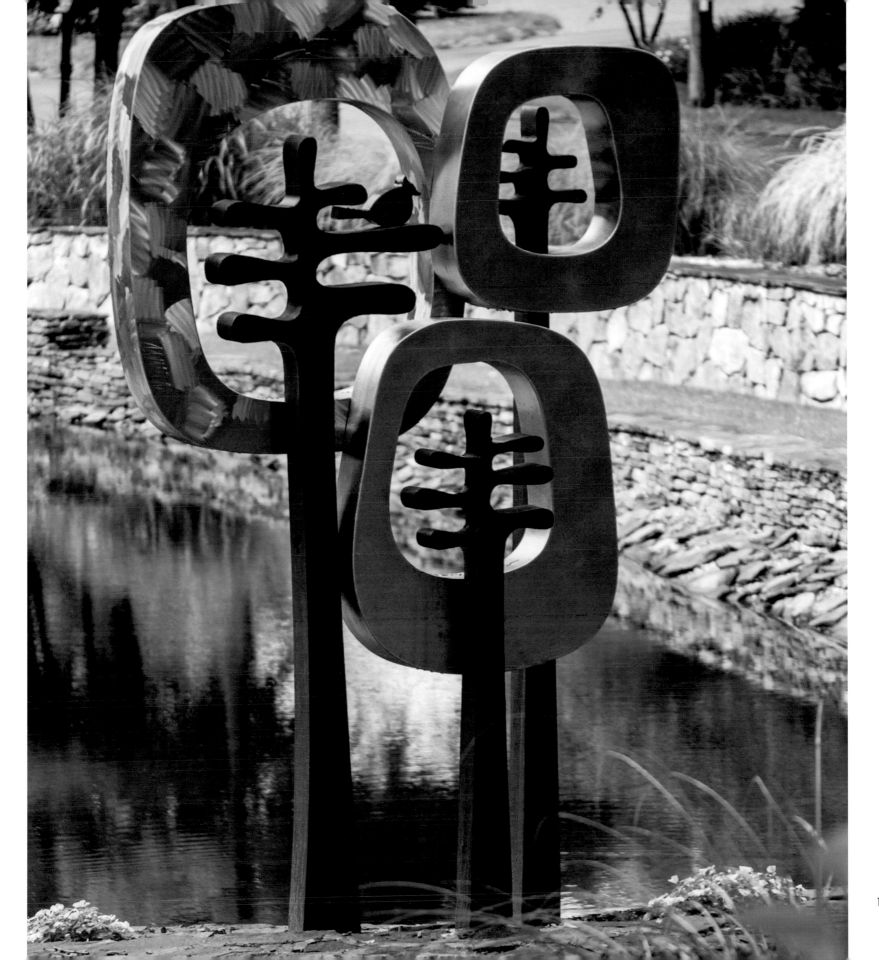

Away

2010 • Stainless Steel • Painted Steel Ball • 93"h x 43"w x 18"d

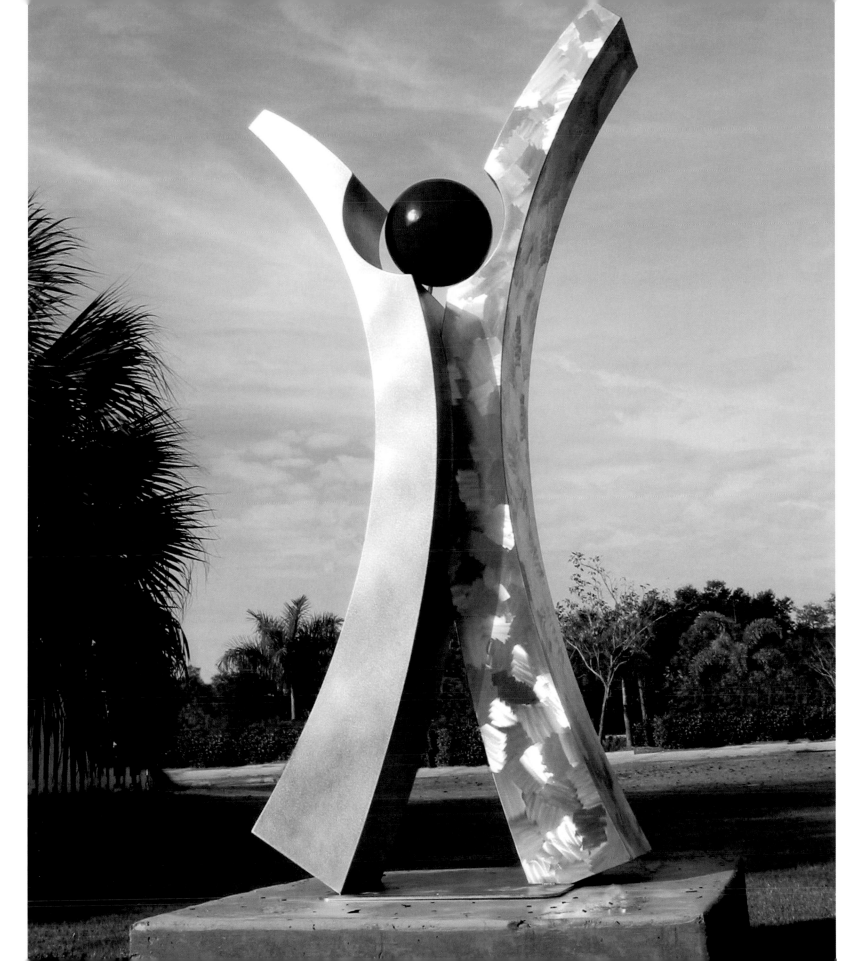

Rodeo Joe

2010 • Cor-Ten Steel • 78"h x 54"w x 18"d

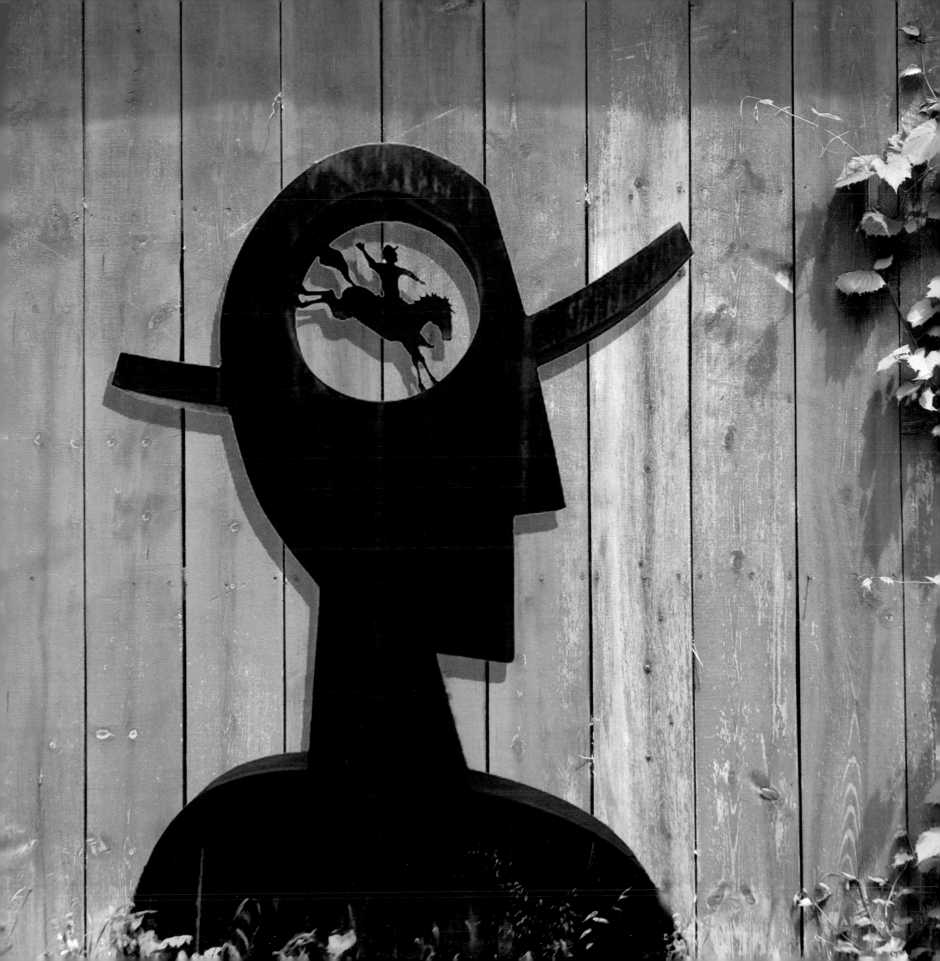

Angel

2010 • Stainless Steel • 74"h x 30"w x 18"d

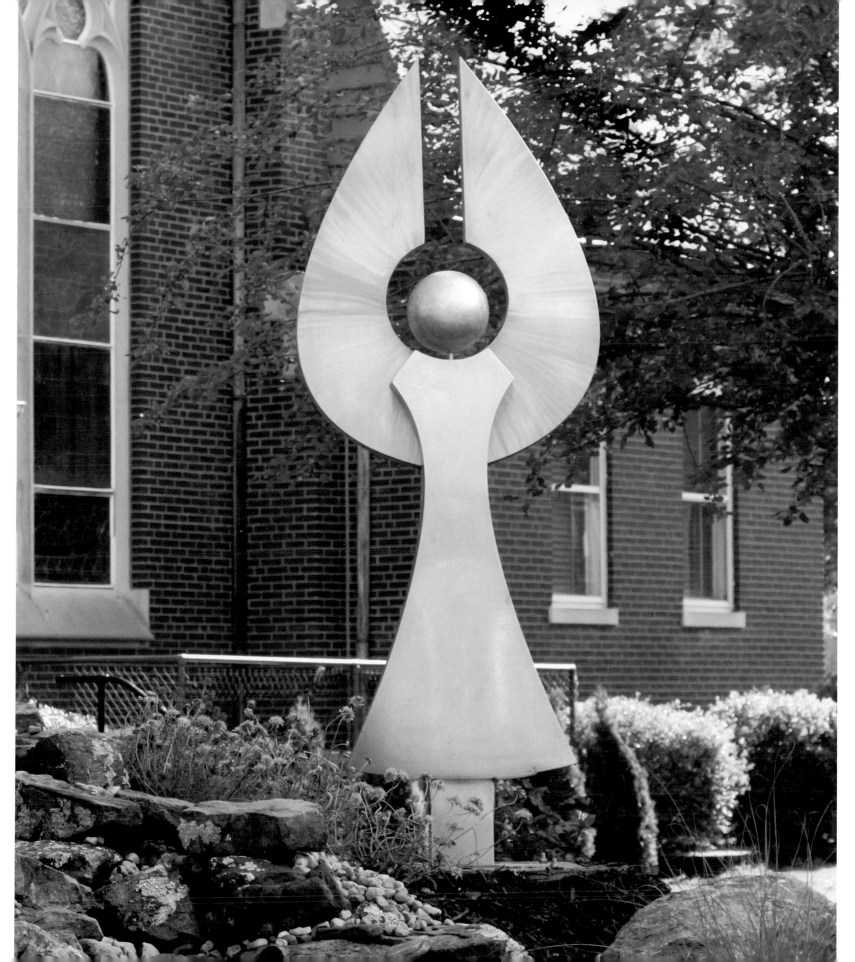

Pendulum

2010 • Cor-Ten Steel • Stainless Steel Rods • 84"h x 32"w x 23"d

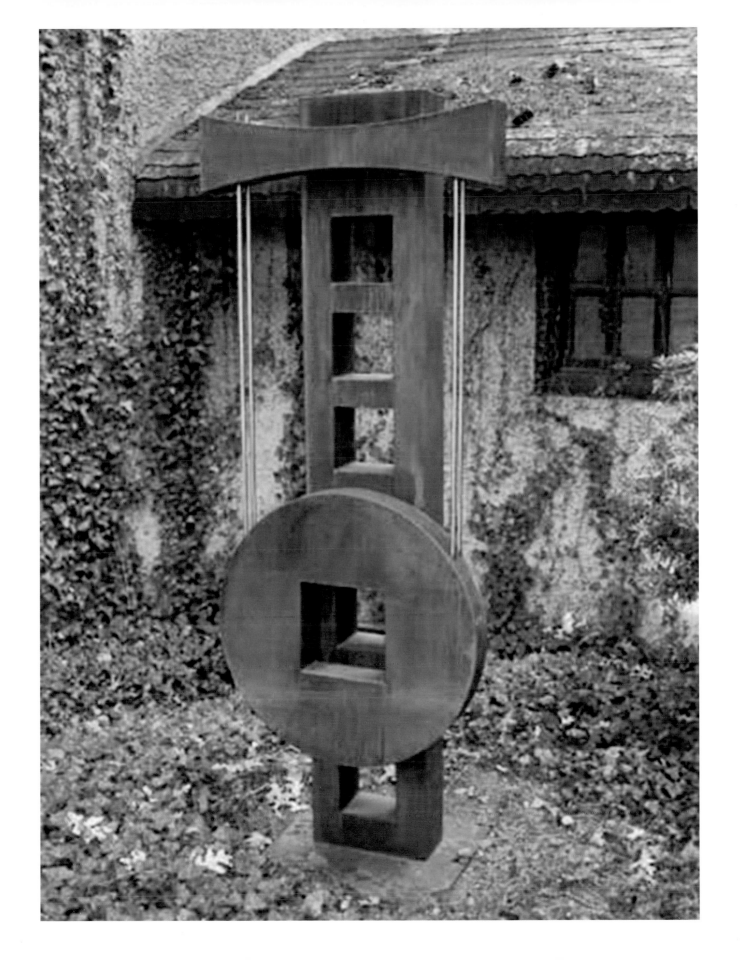

Owl

2010 • Cor-Ten Steel • Painted Steel Ball • 94"h x 52"w x 24"d

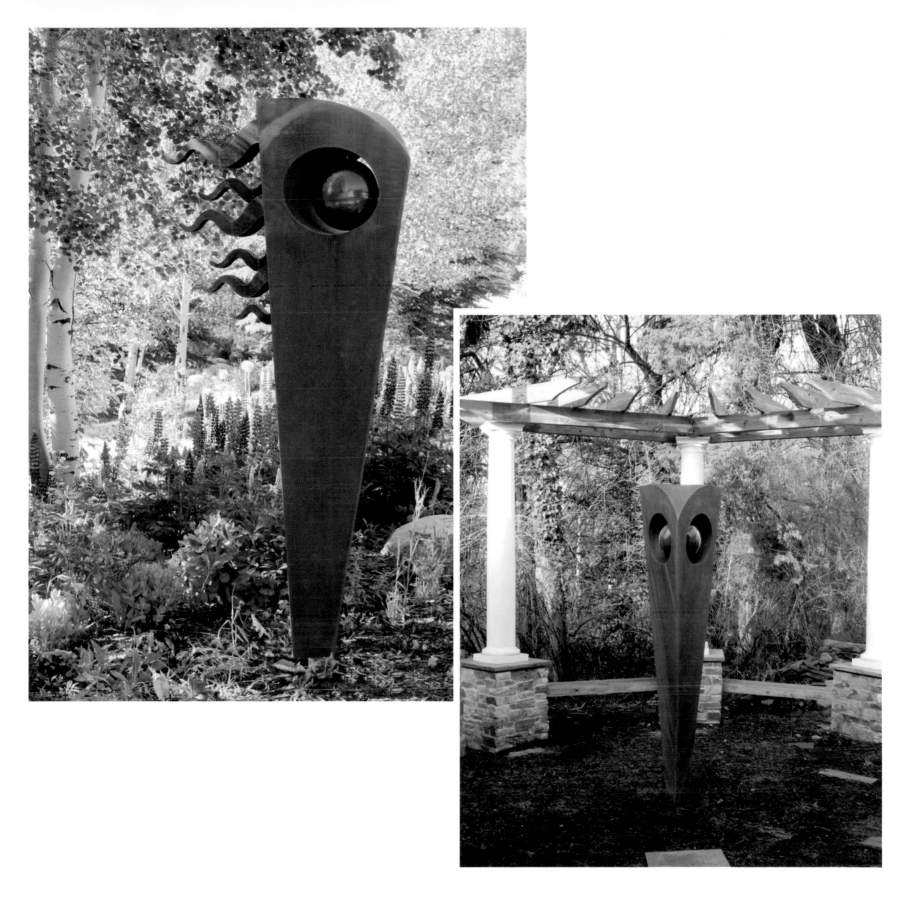

Flower Tower

2011 • Stainless Steel • Glass Flowers • 84"h x 12"w x 12"d

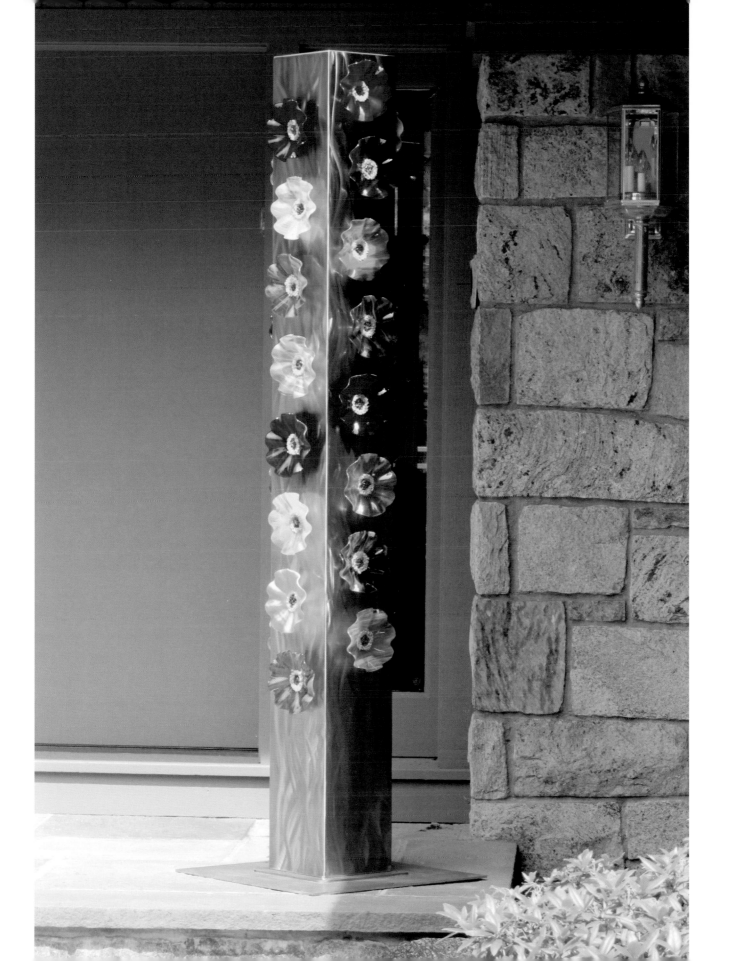

Toy Blocks

2011 • Cor-Ten Steel • 82"h x 12"w x 12"d

119

Monkey

2011 • Mild Steel • 54"h x 25"w x 6"d

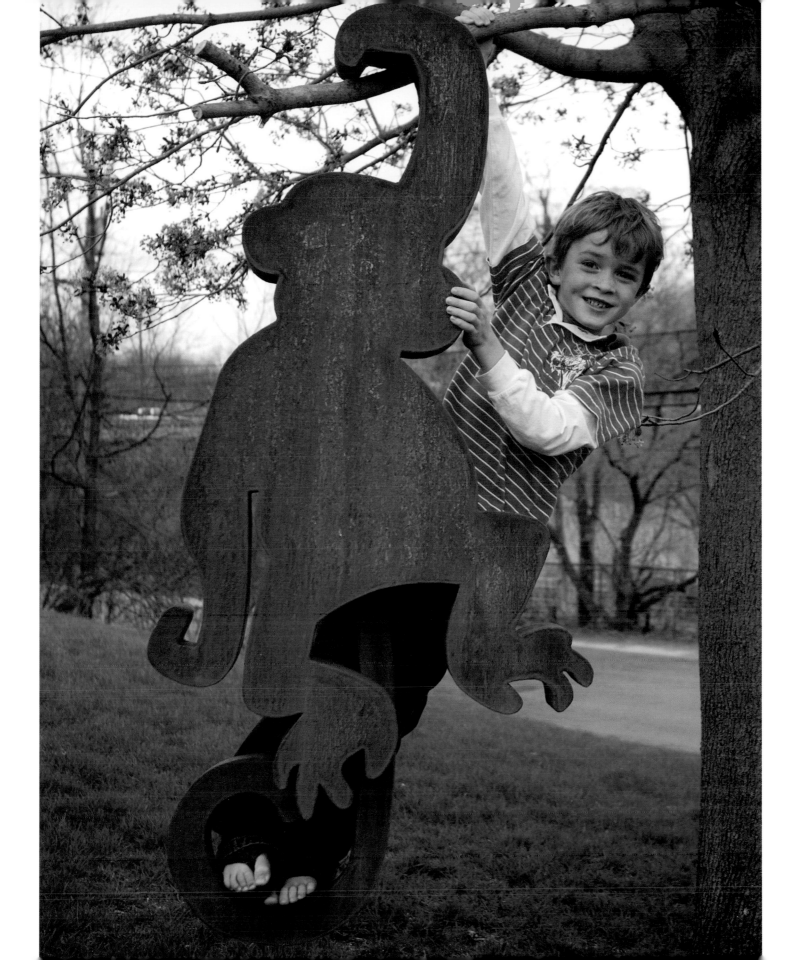

3 Crows in a Tree

2011 • Cor-Ten Steel • Painted Steel Crows • 67"h x 33"w x 30"d

Sparrows

2011 • Cor-Ten Steel • 94"h x 36"w x 40"d

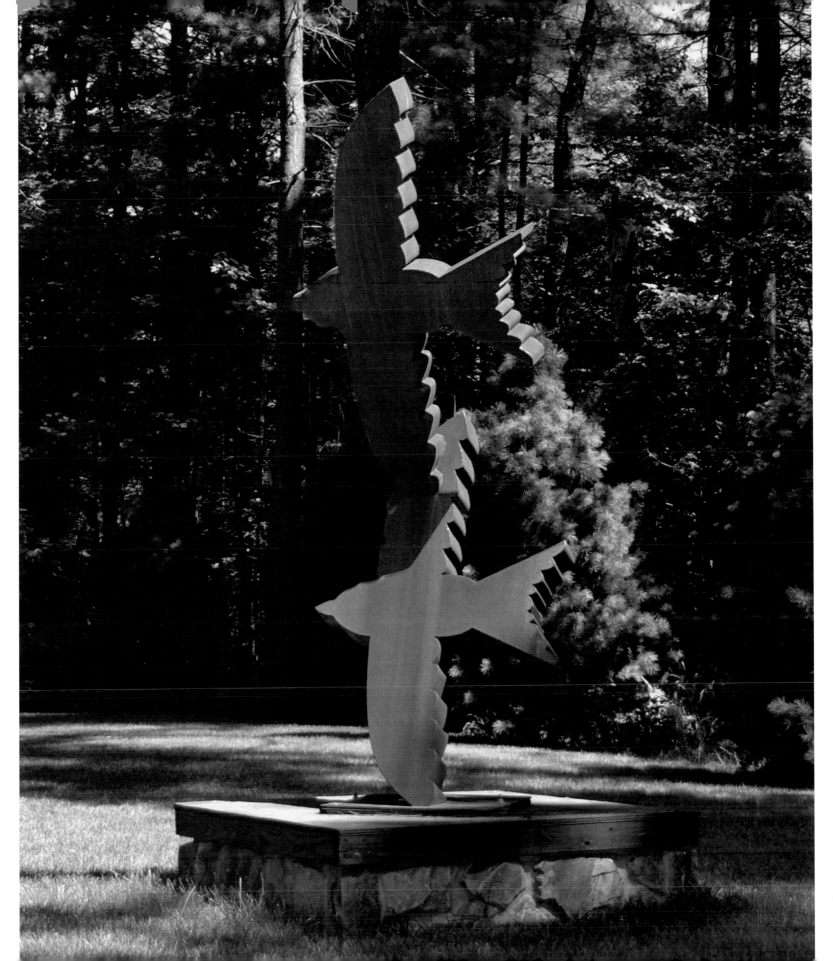

Bird in Hand

2012 • Cor-Ten Steel • Painted Steel Cardinals • 115"h x 58"w x 5"d

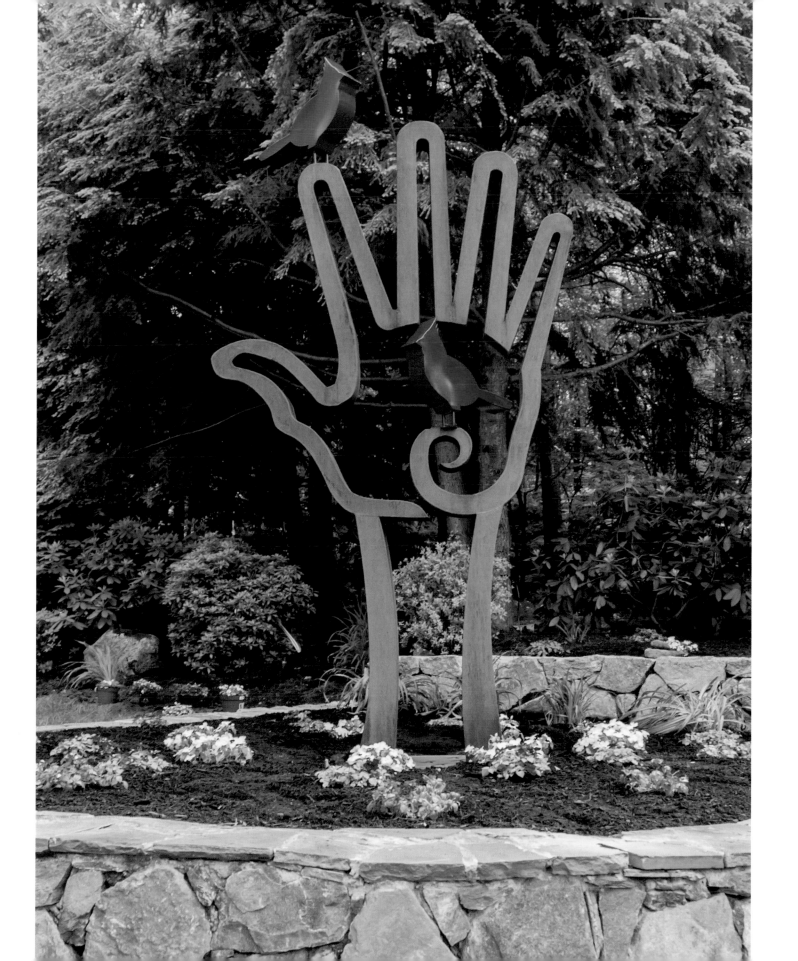

Think and Be Free

2012 • Cor-Ten and Stainless Steel • 115"h x 70"w x 42"d

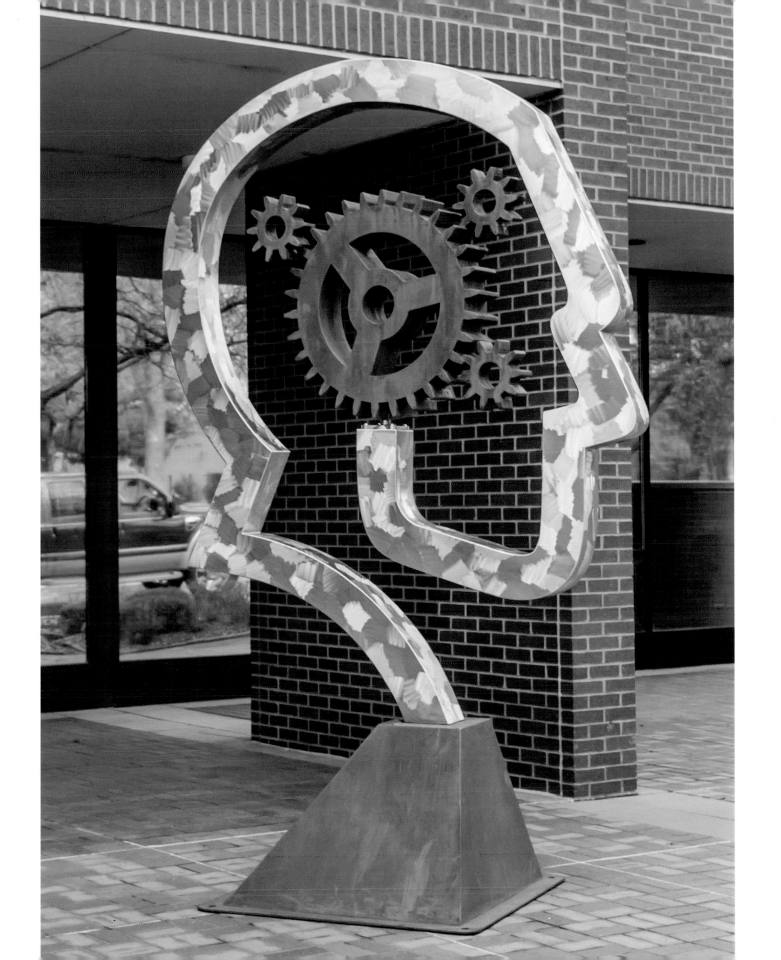

Live Your Dreams

2012 • Cor-Ten Steel • 95"h x 23"w x 23"d

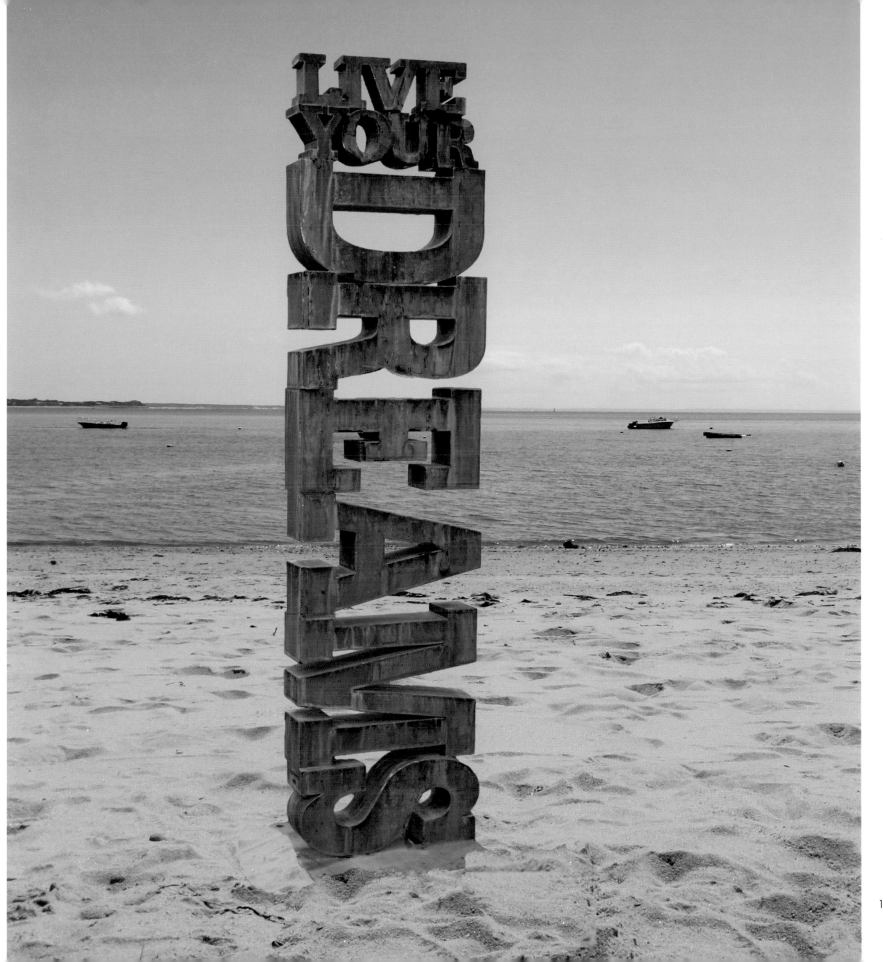

Family

2012 • Cor-Ten Steel • 93"h x 168"w x 8"d

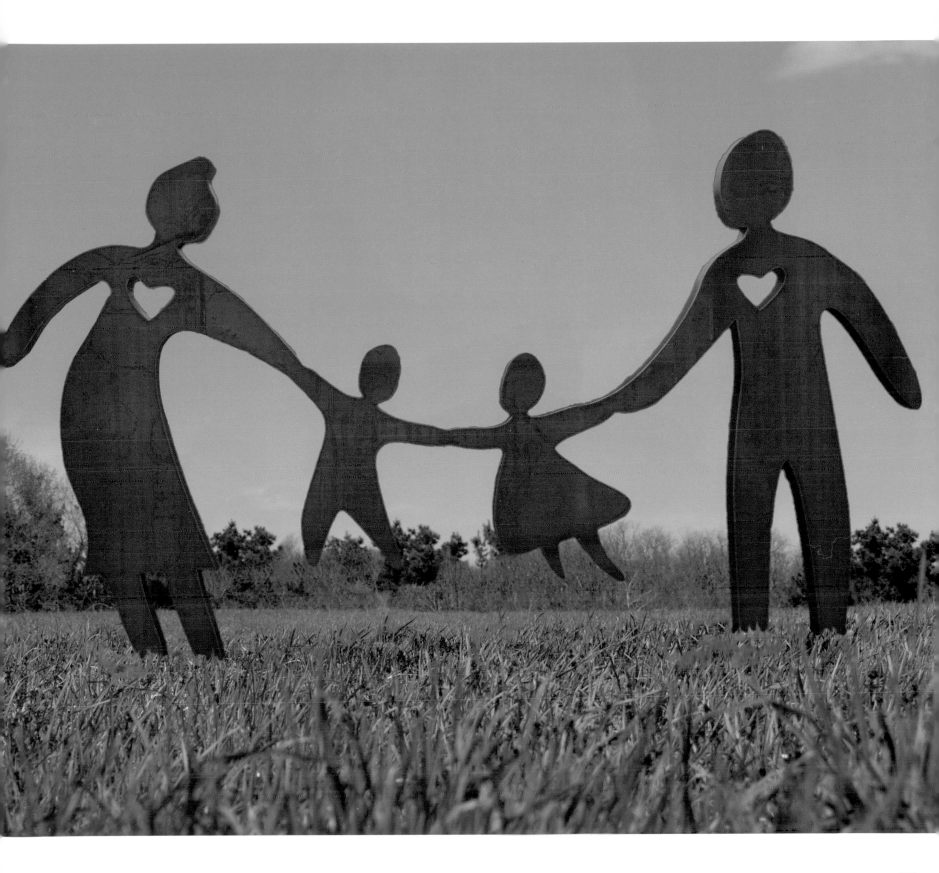

Cherry Blossom

2012 • Cor-Ten Steel • Stainless Steel Blossoms and Painted Steel Cardinal • 90"h x 34"w x 12"d

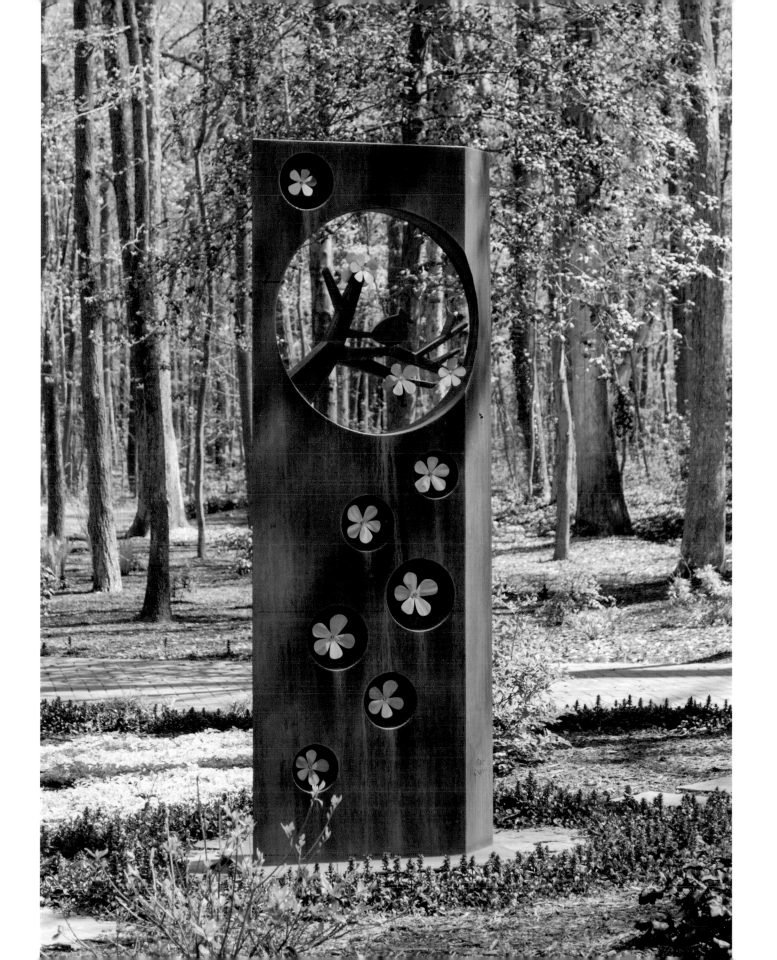

chapter 5
Public Art

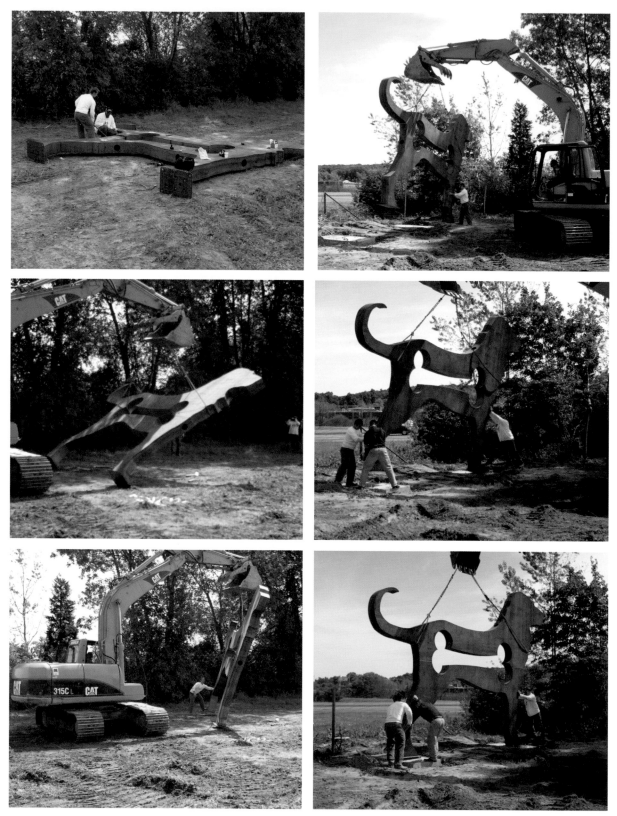

Installation of 16-foot-tall *Highway Dog*

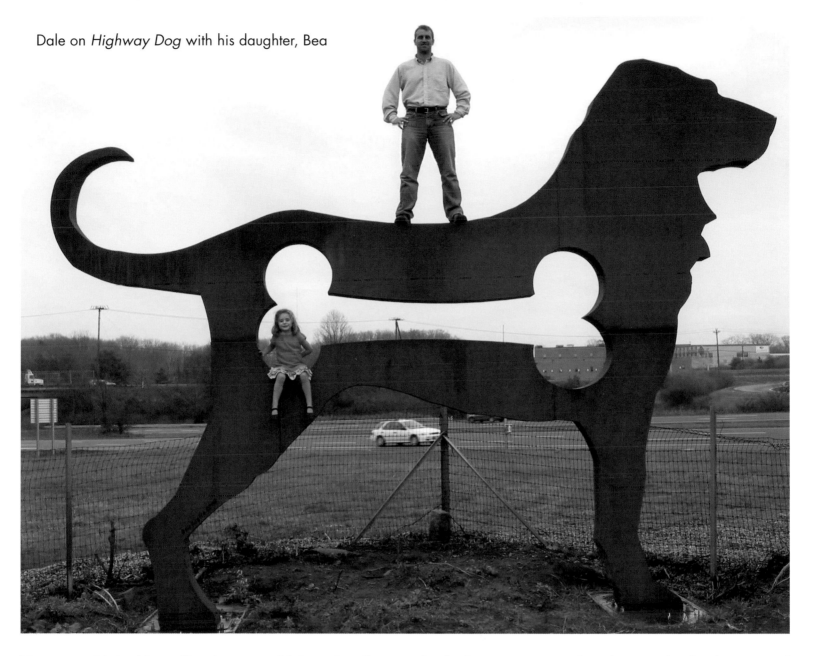

Dale on *Highway Dog* with his daughter, Bea

Having established himself in the art world through gallery exhibits and private sales, the next step in Dale's career took him into the public realm, an area he was eager to explore.

Dale has always felt strongly that art should be accessible to everyone. As rewarding as it is to have his sculptures in private collections, he yearned to see his work displayed publicly. Art is the spark that initiates conversations and feeds the imagination. It enhances the landscape and creates what Dale calls a "mental postcard" in one's memory. His first public pieces were acquisitions from private clients who donated his works to a municipality or had them installed at their office buildings.

Dale was inspired to create more public art. *American Dog* is always a favorite at art shows, so he created a

16-foot-tall dog and installed it near the highway on his family's farm that abuts Route 495 South. It has become a landmark for many who travel this road.

Dale worked with several local cities to have his sculptures displayed publicly. He then started applying for Requests For Proposals, or RFPs, which cities generate when they are looking for artists to showcase. This method of outreach allowed Dale to create public art for many cities nationwide, including San Ramon, California, and Salt Lake City, Utah.

Dale now has over 60 permanent public sculptures throughout the country and more on the way. "Art stimulates

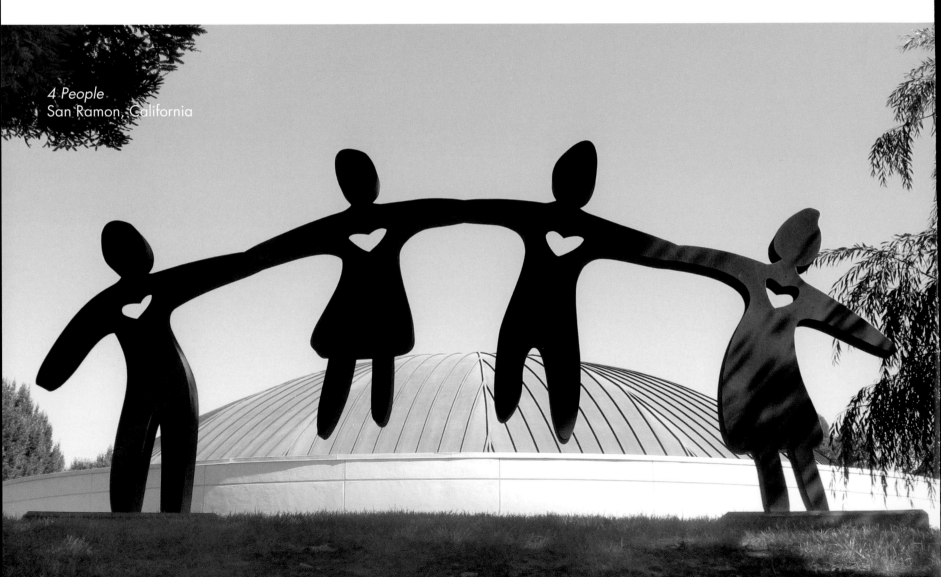

4 People
San Ramon, California

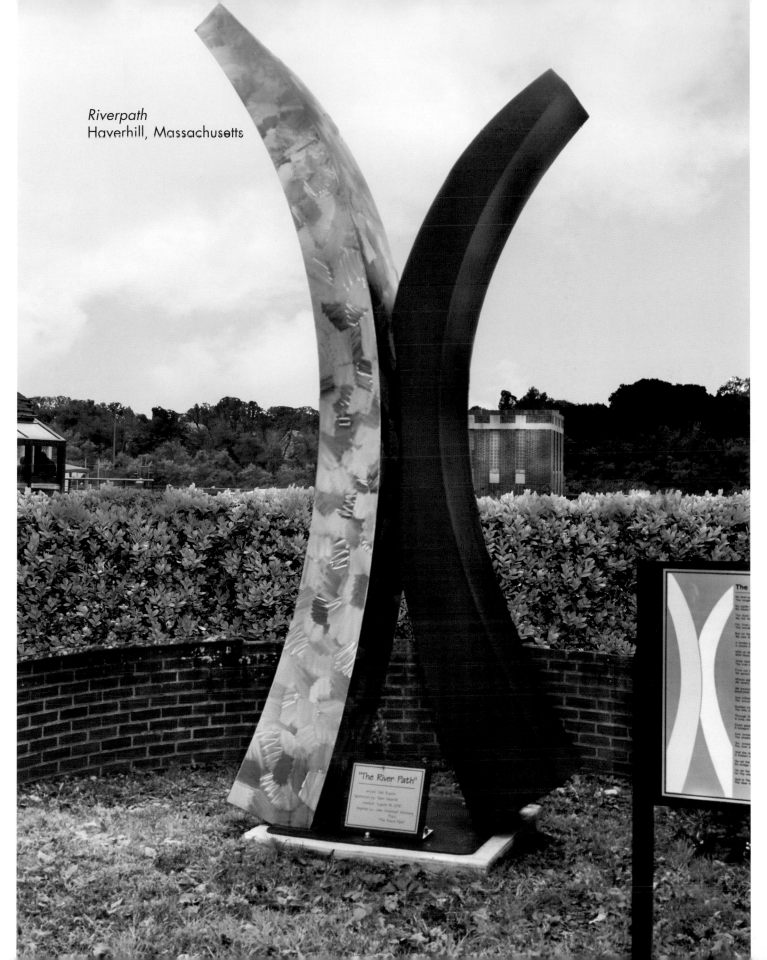

Riverpath
Haverhill, Massachusetts

"The River Path"

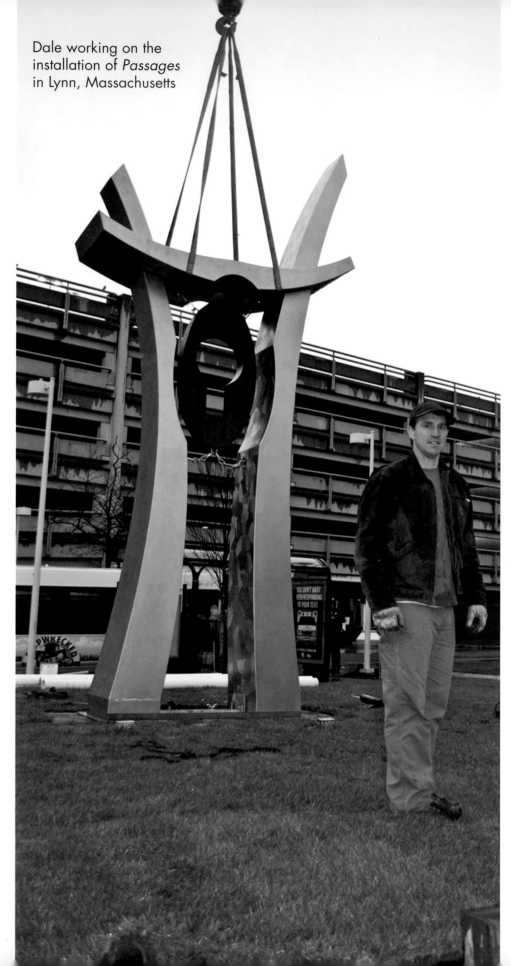

Dale working on the installation of *Passages* in Lynn, Massachusetts

your mind, stimulates conversation, and provides the catalyst for connecting with one another. It is critical that everyone is provided an opportunity for these experiences. It should not be restricted to those who can afford to purchase art," Dale contends.

Adding art to the landscape of public locations has become a mission for Dale; his goal is to have a sculpture in every state by the end of 2015. Currently, his art is displayed publicly in 19 states. Dale's public art can be found in a variety of venues: parks, buildings, dog parks, rail trails and bike paths, veterinarian and medical offices, an aquatic center, and a church, to name a few.

In 2005, Dale was fascinated by *The Gates* in Central Park, by Christo and Jeanne-Claude. Impressed with the scale of the exhibit, he investigated their body of work and found himself inspired to create his own large-scale public sculpture exhibition. This seemed to be the next logical step in providing art for the public. As Dale developed a plan to create an exhibit, the idea of a show that could travel around the country appealed to him. Now he needed to determine what the exhibit would be.

Dale has an affinity for abstract geometrics, but a park full of abstract shapes wasn't

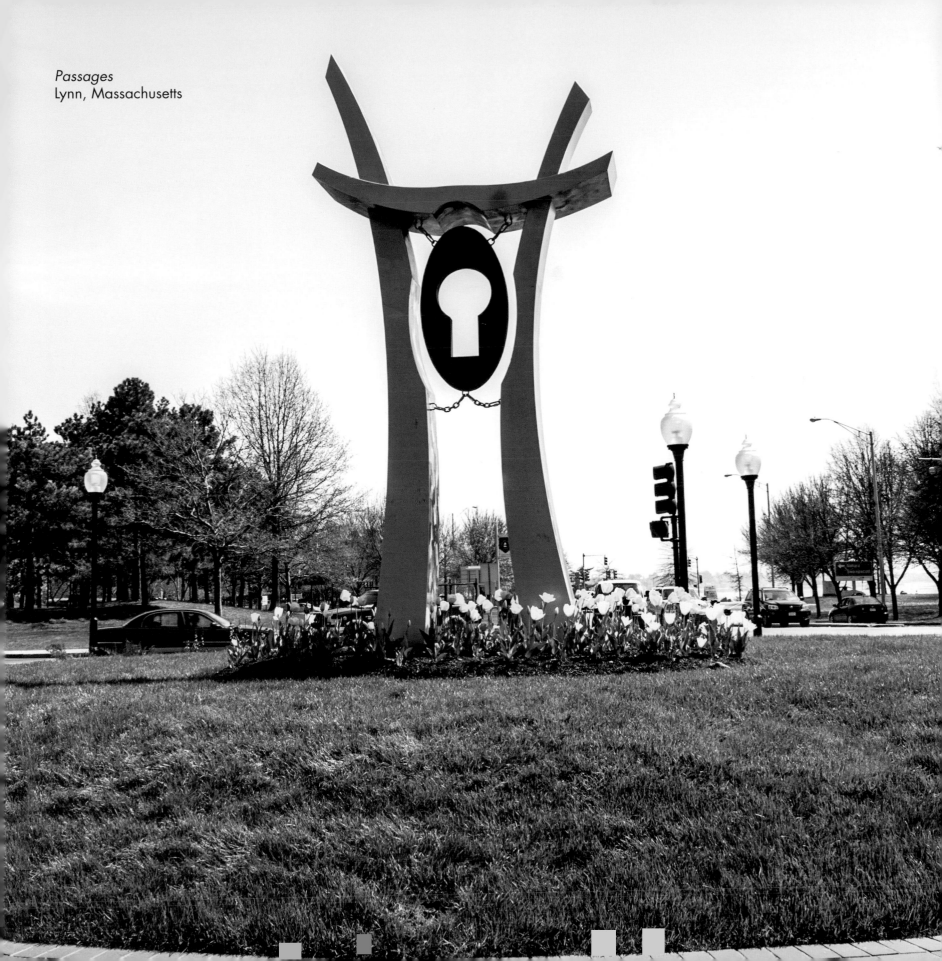

Passages
Lynn, Massachusetts

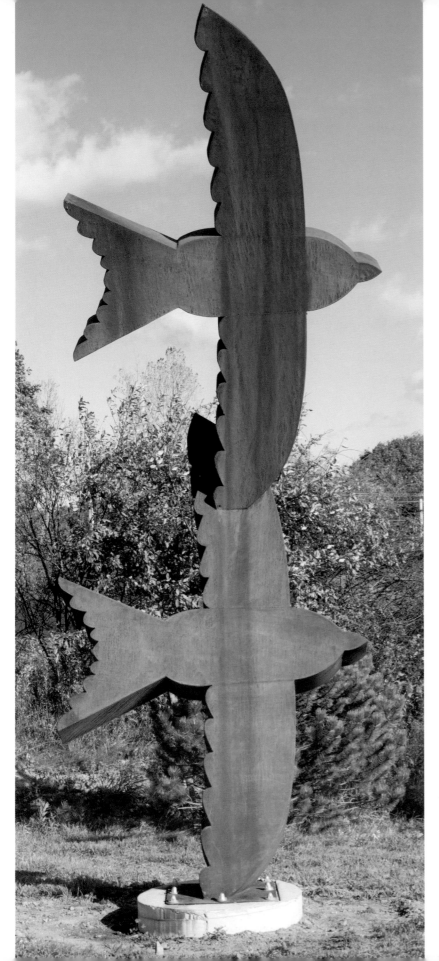
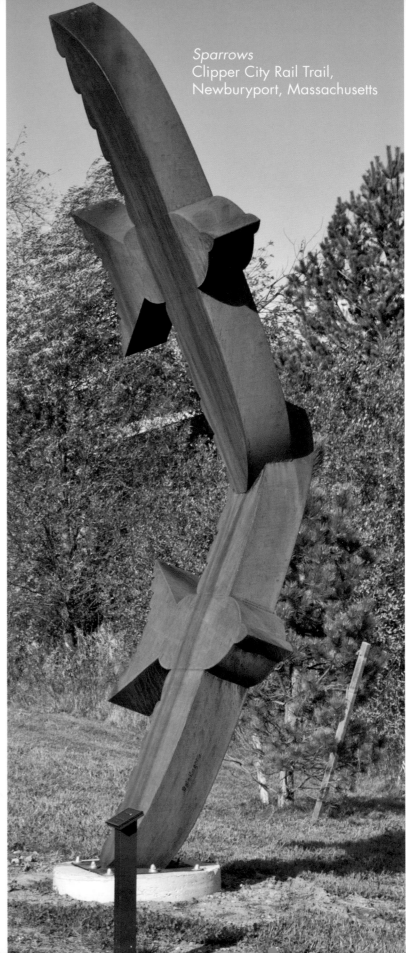

Sparrows
Clipper City Rail Trail,
Newburyport, Massachusetts

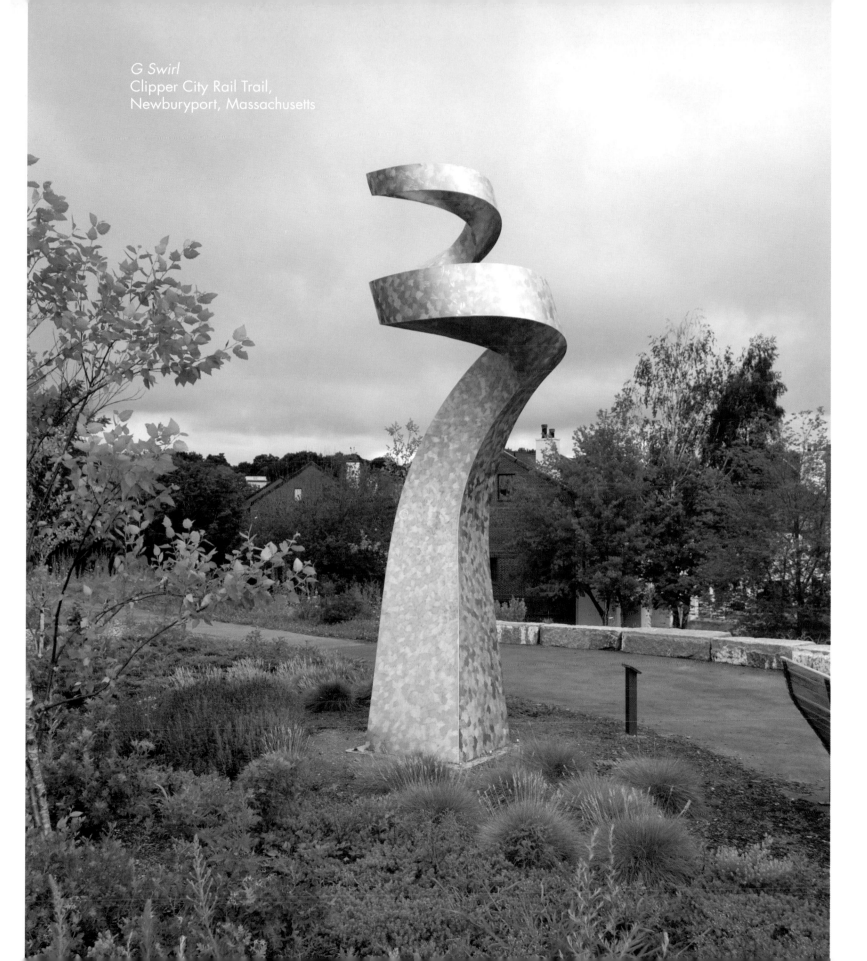

G Swirl
Clipper City Rail Trail,
Newburyport, Massachusetts

145

Another Good Day, Ocean City, New Jersey

Trapped Ball, Ocean City, New Jersey

going to provide the "grab" and "lure" that he was searching for. He knew that he wanted to use his highly successful *American Dog* sculptures as the basis for this first exhibit, as the dog appeals to people crossing many demographics. To achieve the impact he desired, Dale envisioned a pack of 100 dogs, each eight feet tall, that would provide spectators with a dog's perspective of the world—normally a dog wanders through a pack of people; here, people would wander through a pack of dogs.

In 2008, Dale hired Kelly Martin, a freelance marketing consultant, to facilitate getting his work exhibited in large city parks. Ideally, Dale wanted to display his pack of dogs on Boston Common but, after meeting with the appropriate officials, he learned that an artist needed to start small and

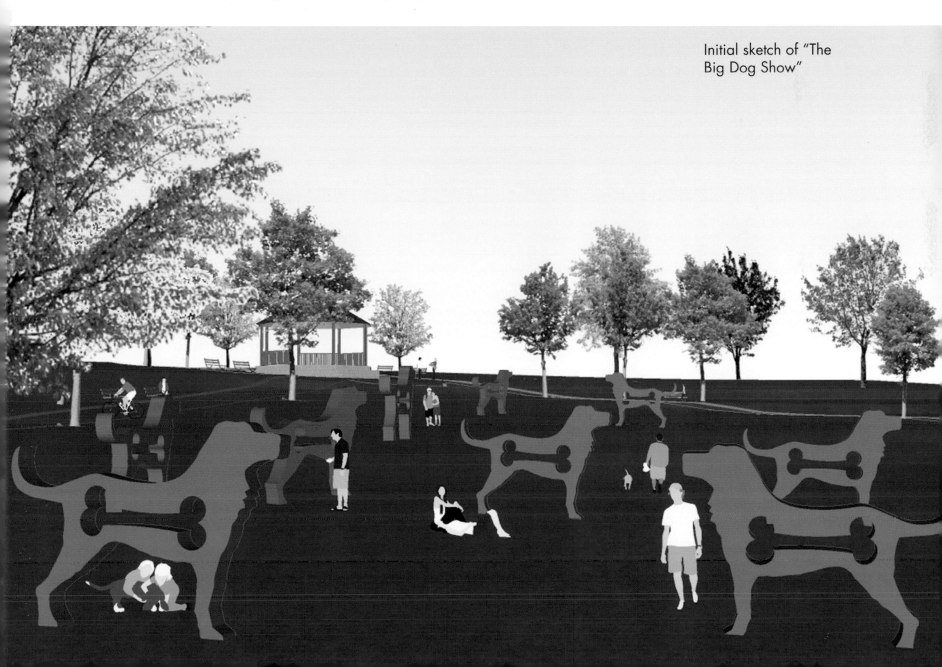

Initial sketch of "The Big Dog Show"

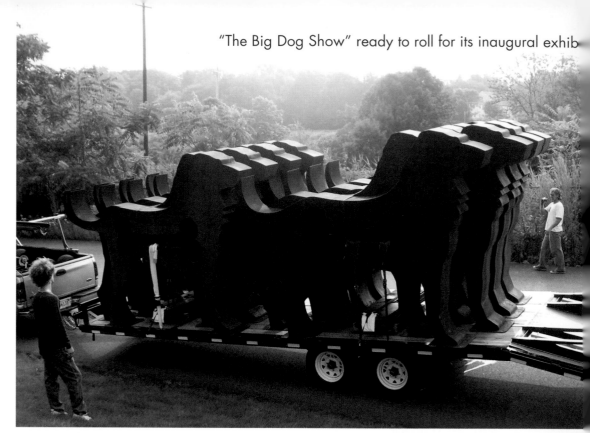

establish a proven track record before being granted a venue of this magnitude. Dale and Kelly were advised that they would need to partner with a nonprofit organization, gain corporate funding to help with expenses, and establish experience with public art exhibits. No one was going to let a relatively new artist who hadn't proven him or herself first set up an exhibit of this scale.

Dale and Kelly decided to downscale their plans and perfect the exhibit on a smaller scope before moving into this larger realm. In 2009, Kelly secured six cities in three New England states to host "The Big Dog Show." That summer, over the course of six weeks, the show traveled to each park, staying a week in each locale. The cities and towns planned different events around the show and coordinated with varying nonprofit organizations to raise awareness and funds.

The work involved in preparing for these public shows goes beyond the physical pieces of art. It also includes getting approval from municipalities and the

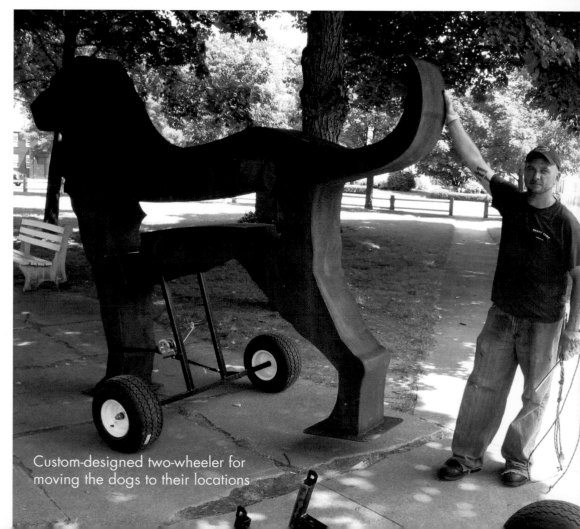

Custom-designed two-wheeler for moving the dogs to their locations

logistics of transportation, installation, and breaking down the works at the end of the show.

The trailer to transport the dogs was delivered a few days before the first show. Dale had to quickly design the hoist system and frame for the trailer. The installation and dismantling had to be kept simple, so that grassy areas would not be torn up. It would be easier to use a forklift or some other mechanical device, but part of the "art" is keeping the transport simple and nondestructive. He designed and built custom two-wheel handcarts that could painstakingly move the dogs from the trailer to their locations and back again.

Each stop proved to be a case study, and Dale worked to perfect the installation process and the logistics of

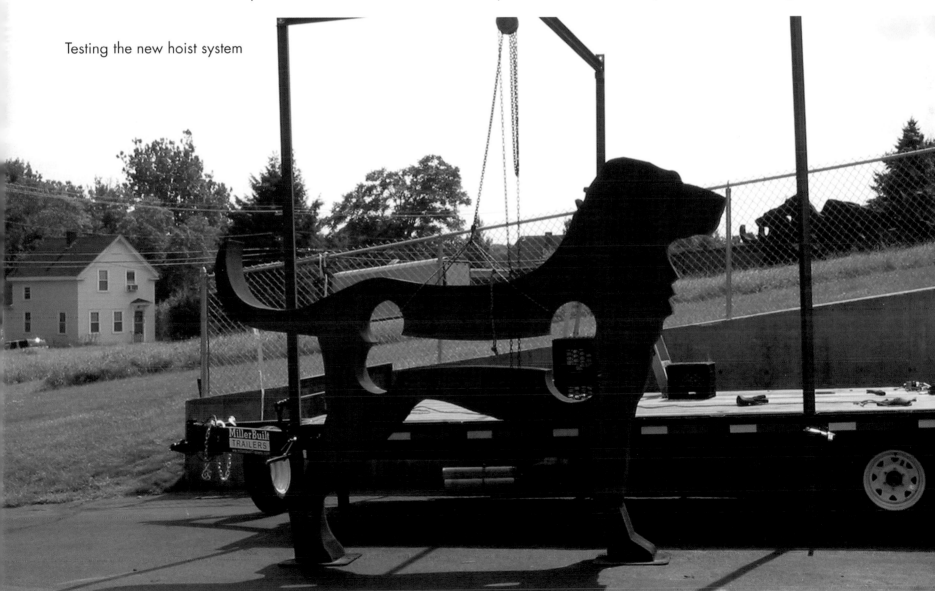

Testing the new hoist system

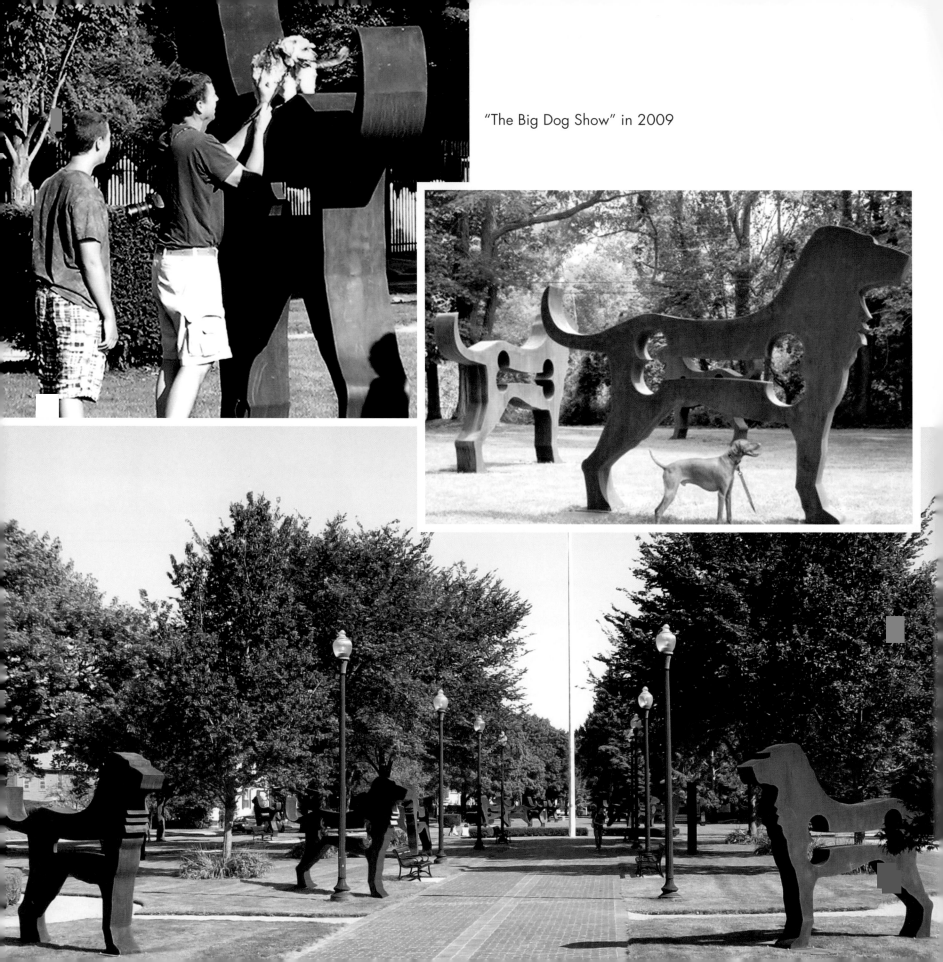

"The Big Dog Show" in 2009

"The Big Dog Show." The show continues to book venues and travels around the country. In 2010, it made a stop in Grand Rapids, Michigan, to be a part of the city's ArtPrize event. ArtPrize began in 2009 and is a three-week exhibit of works by artists from around the world. Artwork is displayed throughout the city, both indoors and out, and the public gets to vote for their favorite pieces, which ultimately determines the grand-prize winner.

Remembering what he was told in Boston, Dale was one of the few artists represented who chose to partner with a nonprofit organization. He teamed up with the Humane Society of West Michigan and helped raise awareness and funds for their organization.

Dale developed the concept for his next public art exhibit while at ArtPrize 2010. He toured Grand Rapids, looking

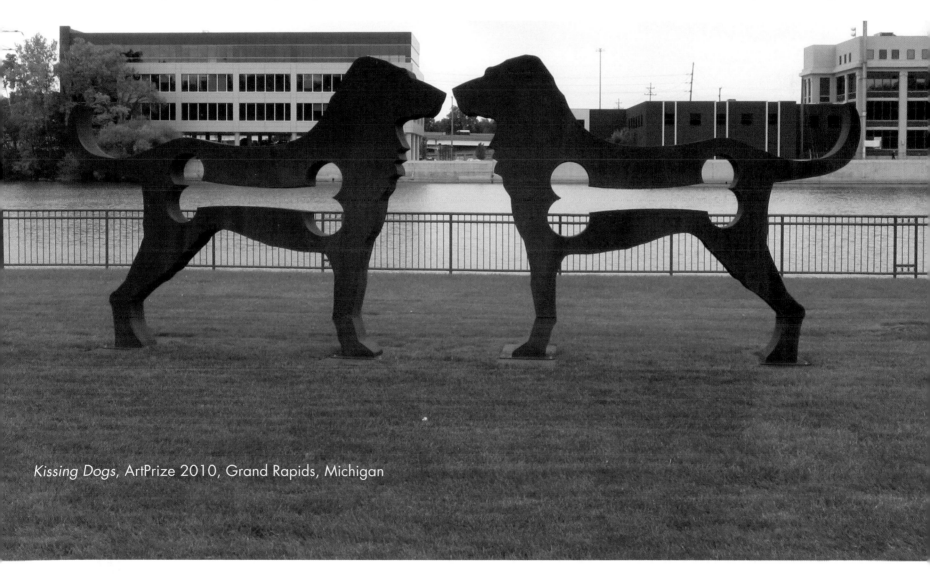

Kissing Dogs, ArtPrize 2010, Grand Rapids, Michigan

THE BIG DOG SHOW

Dale Rogers NEW ENGLAND'S LARGEST SOLO SCULPTURE EXHIBITION

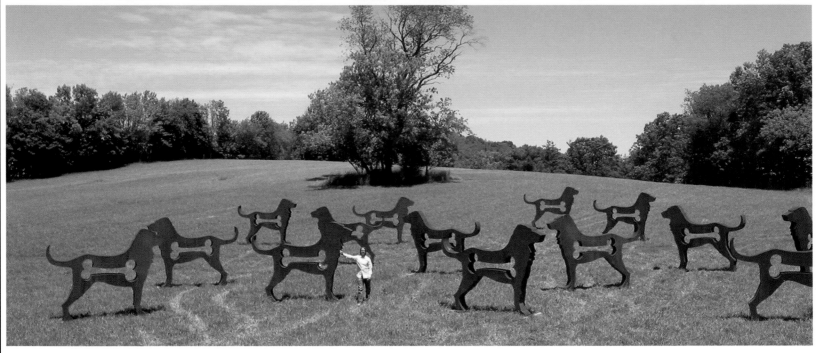

Exhibition Dates:

August 6 - August 11
Haverhill, MA - Bradford Common

August 13 - August 18
Portsmouth, NH - Peirce Island

August 20 - August 25
Ogunquit, ME - Littlefield Park

August 27 - September 1
Newburyport, MA - Waterfront

September 3 - September 8
Beverly, MA - Beverly Common

September 10 - September 15
Lowell, MA - Jack Kerouac Park

FREE

ONE COUPON FOR AN AMERICAN DOG KEYCHAIN

BY DALE ROGERS

SEE BACKSIDE FOR DETAILS

Marketing materials from the initial exhibitions of "The Big Dog Show," which debuted in 2009

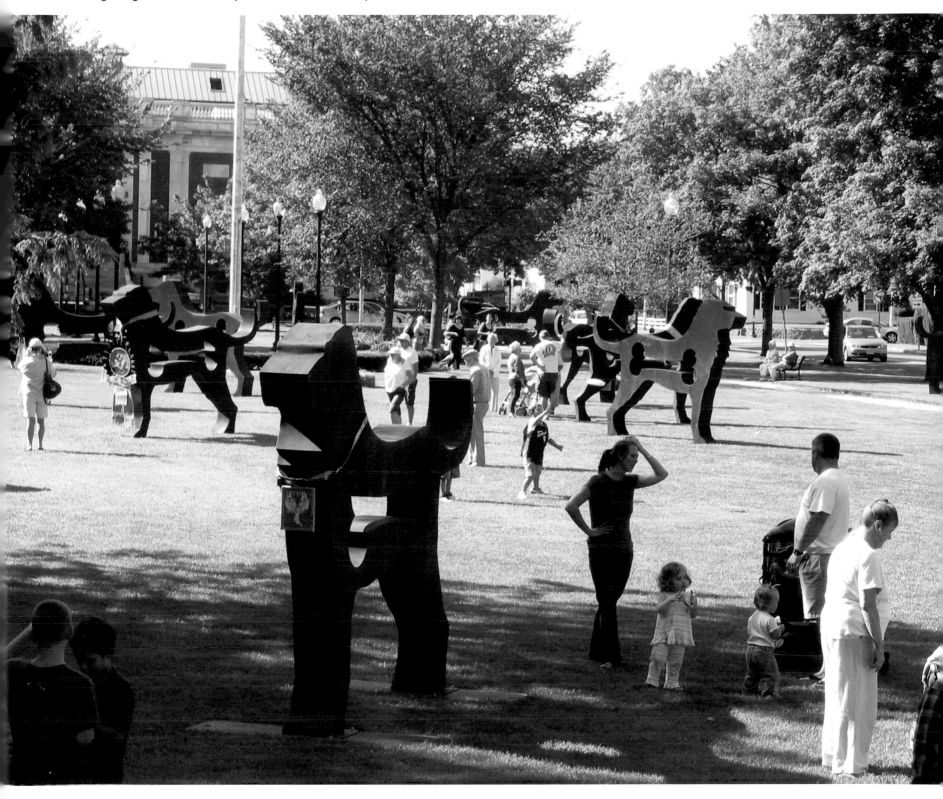

at the various venues available to artists. One site, the Blue Bridge, caught his eye because he felt it was underutilized. He thought it had great potential and could envision sculptures hanging from the girders and beams while leaving the bridge deck open for pedestrians. Dale's art is usually large, heavy, and bolted to the ground. Designing a sculpture intended to hang would be a welcome challenge. He and his team took some time to walk the bridge and discuss the conceptualization of the show. Before Dale even left the site, he was designing "Metal Monkey Mania" for the Blue Bridge at ArtPrize 2011. Monkeys are fun and iconic and made sense as a sculpture that needed to hang. He envisioned them dangling in chains of two or three, by their hands and tails.

Henry Matthews, Director of Galleries and Collections at Grand Valley State University, was the sponsor of the Blue Bridge and was crucial in securing the bridge as the location for "Metal Monkey Mania." Henry's support for this project was above and beyond anything Dale had hoped for. One year later, Dale was on the bridge installing 100 monkeys suspended from the girders.

Dale decided to cosponsor this exhibit with the Humane Society of Western Michigan once again, even though ArtPrize does not require artists to have the support of a nonprofit.

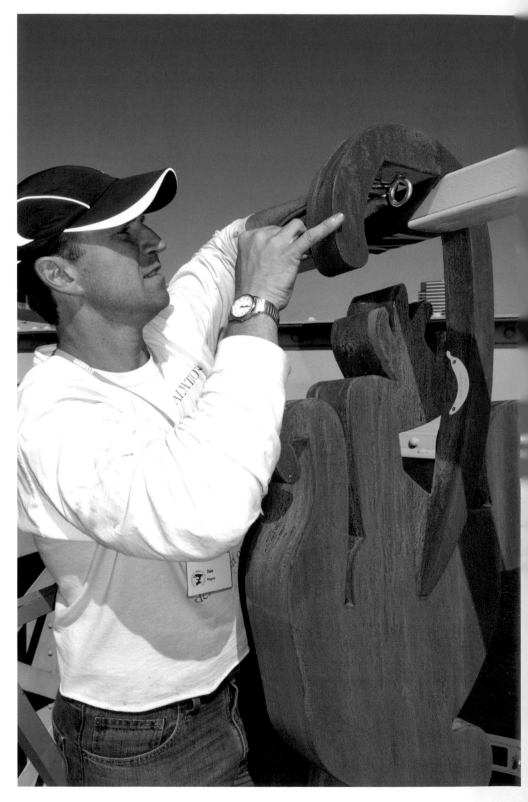

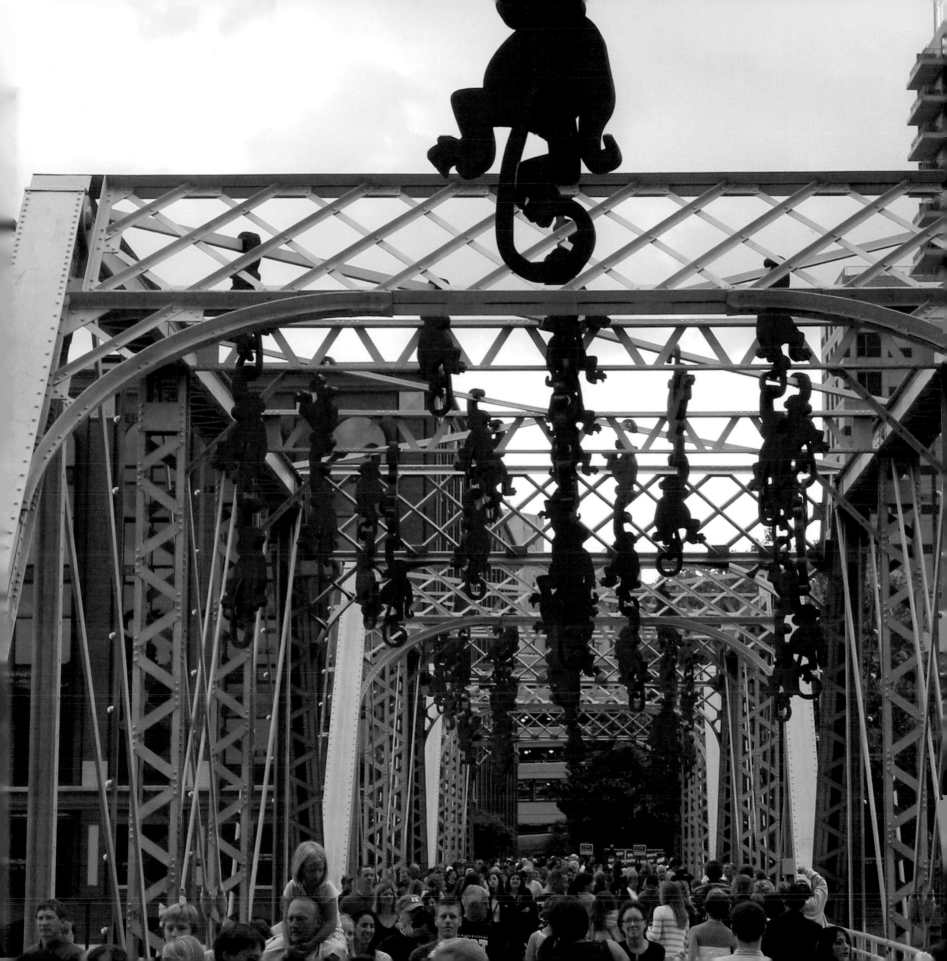

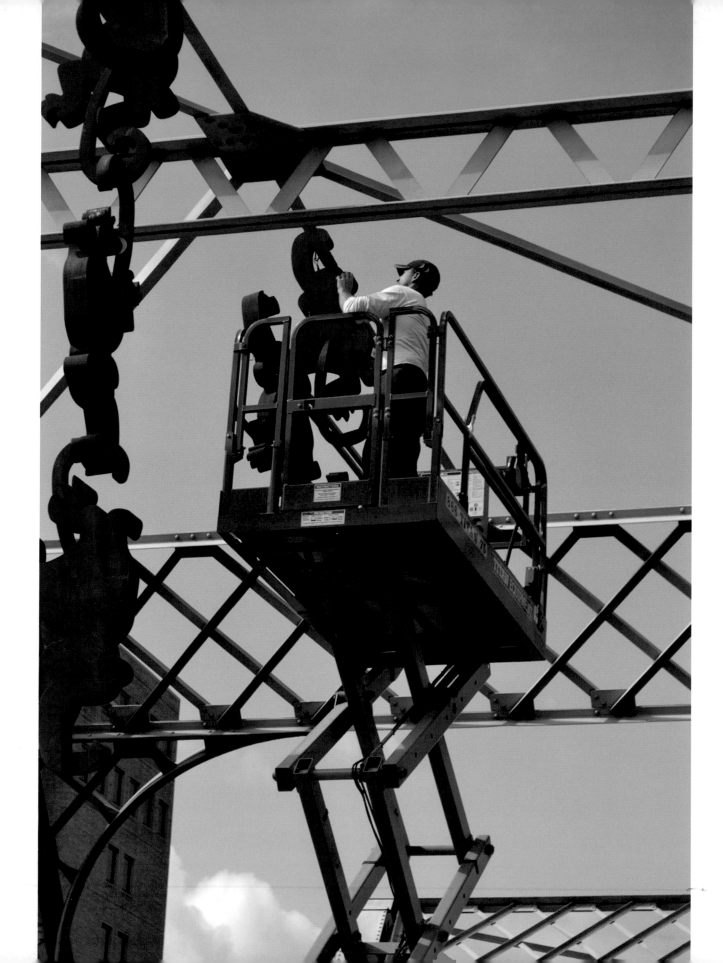

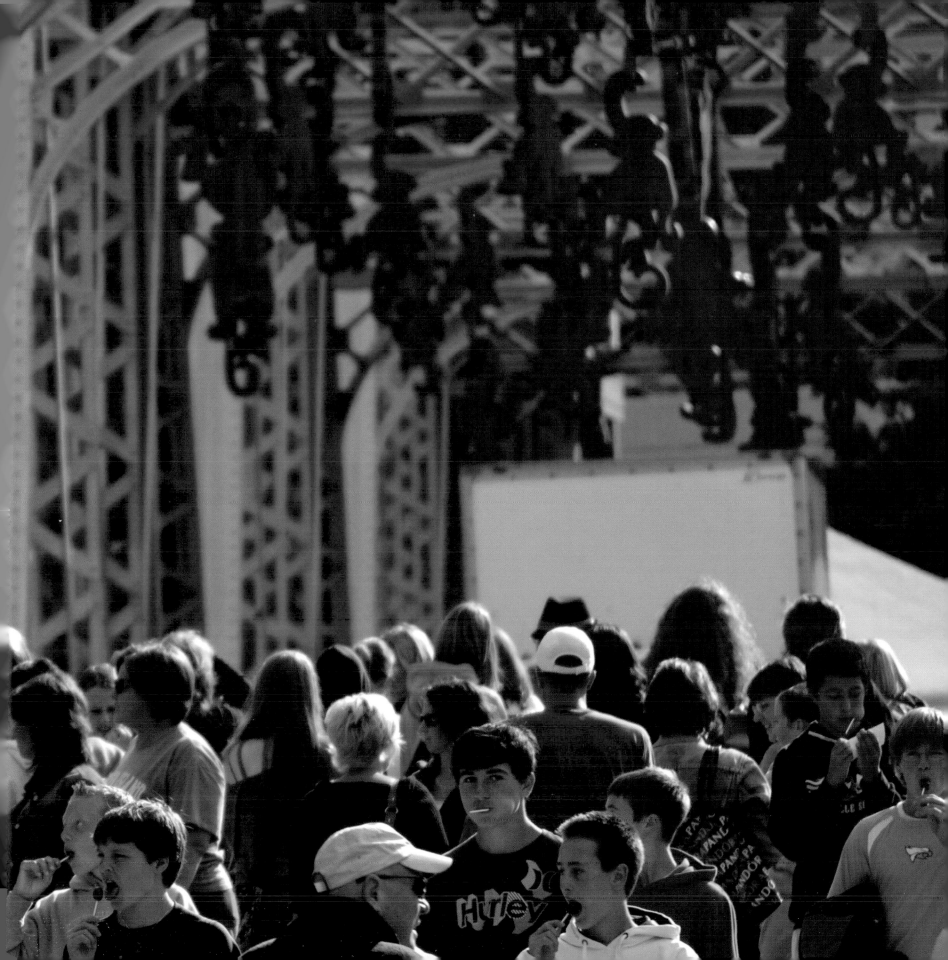

As he had the prior year, Dale started planning his 2012 ArtPrize exhibit while he was there in 2011. Dale truly enjoyed participating in ArtPrize and is continuously looking for opportunities to do more large-scale exhibitions. He continues to challenge himself to push the boundaries of his designs and incorporate new forms of media.

Dale's philosophy for his business involves expansion. The first questions he always asks himself are, "What is there a need for?" and "What can I offer to help fill that need?" Approaching his art in this manner allows Dale room to evolve. He likes to keep projects open ended so he can return to them and see how they can best be utilized in the current environment. Dale's business degree is always a key component of any piece of art or exhibition. Can he create art that can satisfy a business plan and vice-versa? On its own, a project may not make sense, but in combination with the rest of his portfolio, does the project meet the long-term goal of expansion? "The Big Dog Show," created in 2009, did just that. It did not make economic sense at the time, but it allowed Dale to start expanding into large-scale exhibitions and develop a proven track record for his current and future exhibitions.

This approach to art and business has worked well for Dale; he is always looking forward and working to reach the next level in expanding his business. One can see the evolution of Dale Rogers Studio: At the outset, he primarily created small-scale and two-dimensional works, such as clocks and wine racks, and progressed to craft three-dimensional sculpture on a larger scale. Galleries began representing him and featuring his work at solo exhibitions, and he continued to push his business further by bringing his work to art shows and selling it both wholesale and retail. Public art and public exhibitions were the next expansion focus. Both of these have grown considerably in the past few years and are now a permanent component of Dale Rogers Studio. Currently, Dale is exploring the possibility of museum exhibitions and international exhibits. What a long way he has come.

"This ongoing plan to expand leaves us with unlimited potential," says Dale. One thing is certain: Nothing stays static at Dale Rogers Studio.

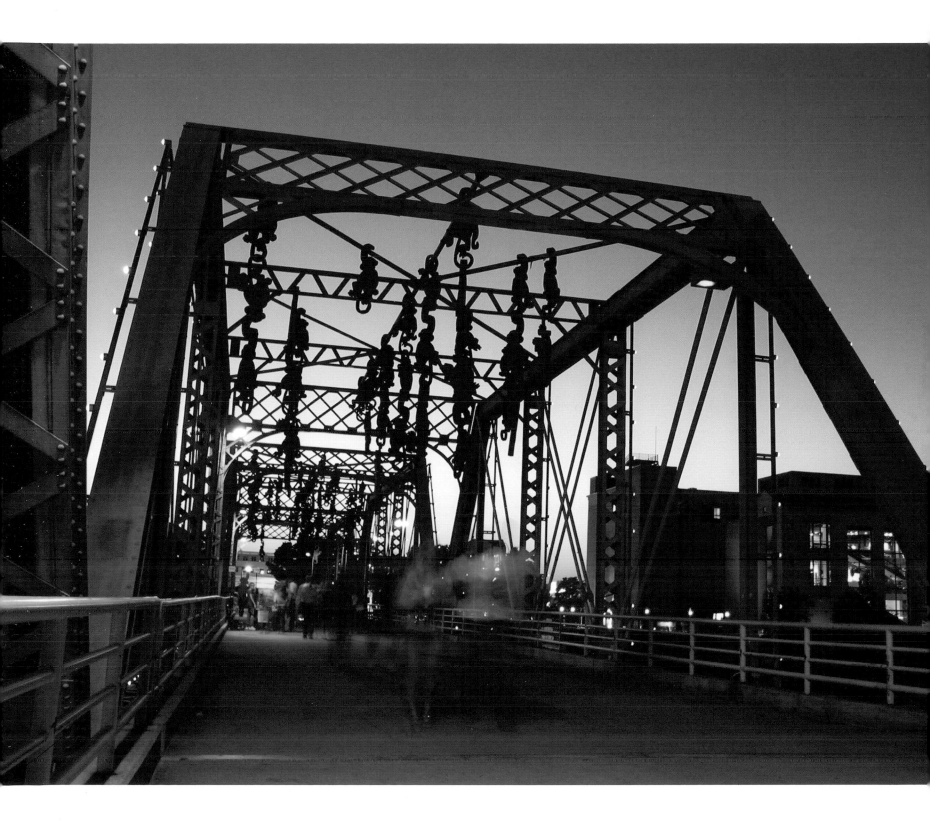

Index

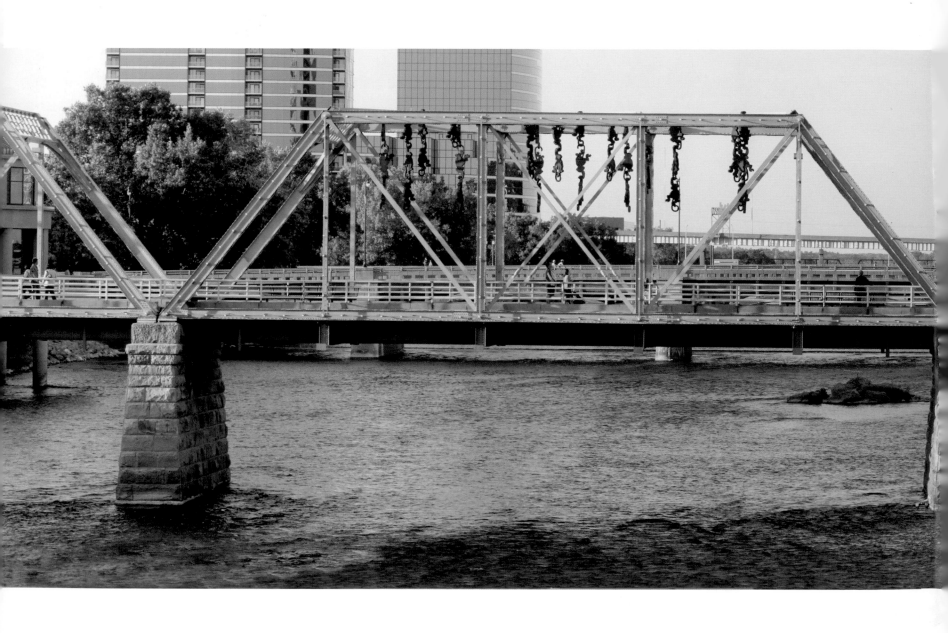